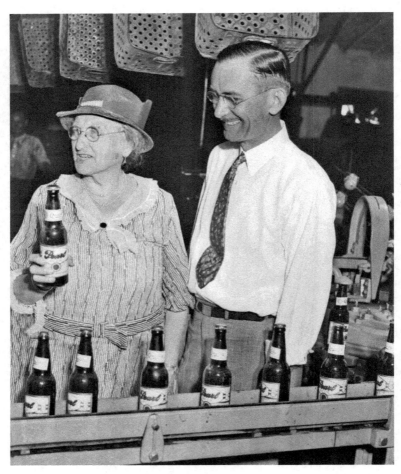

Emma Koehler with Brooks McGimsey and bystanders watching the first bottles of Pearl Beer leave the vats after the repeal of prohibition. *San Antonio Light*, August 29, 1933. L-0036-J, UTSA Library Special Collections

Mary Carolyn Hollers George

Author of *Rosengren's Books*, *O'Neil Ford: Architect*, et al.

State ⬥ House Press

State House Press
The Texas Center
Schreiner University
Kerrville, TX
325-660-1752
www.mcwhiney.org

Cataloging-in-Publication Data

Names: George, Mary Carolyn Hollers, author.
Title: Pearl sets the Pace / Mary Carolyn Hollers George.
Description: First edition. | Kerrville, TX: State House Press, 2020. | Includes
 bibliographical references and index.
Identifiers: ISBN 9781933337890 (soft cover); ISBN 9781933337913 (e-book)
Subjects: LCSH: Pearl Brewing Company – History. | Beer industry – Texas – San
 Antonio – History. | Pace Foods – History. | San Antonio (Tex.) – History.
Classification: LLC HD9397.U54 (print) | DDC 388.47663

Use of the Pearl logo is courtesy of the Pabst Brewing Company.
Use of the Pace logo is courtesy of the Campbell Soup Company.

First edition 2020

Cover design by Andrea Katzberg Bullock of Big B Press.
Page design and production by Allen Griffith of Eye 4 Design.

Distributed by Texas A&M University Press Consortium
800-826-8911
www.tamupress.com

A FEW WORDS ABOUT KIT GOLDSBURY AND *THE PEARL*

I had the privilege of working for Kit Goldsbury for twenty years at both Pace Foods and Silver Ventures. Kit is a true visionary with an ability to envision things others simply cannot or do not see. He foresaw how a small hot sauce product named Pace Picante Sauce could compete with major consumer goods corporations and become the largest brand of Mexican food sauce in the country. He also saw how a piece of property where the old Pearl Brewery was located—which had been for sale for many years—could be transformed into a major attraction for tourists and locals alike. His development of "the Pearl" would make a major change to the footprint of his hometown of San Antonio, Texas.

Realizing this project did not come easy, as there were many challenges to face, issues to resolve, and obstacles to overcome. Kit was required to purchase Pace Foods several times from various in-laws and from his ex-wife, Linda. With each purchase the price of the company increased many fold over its previous price. Transforming the old Pearl Brewery into a first-class destination required many resources and a great deal of cooperation with the city. Hotel Emma in particular, the crown jewel of Pearl, was the fruit of research stretching over many years. Kit traveled extensively and stayed in some of the world's finest hotels, and as he did he noted everything that made each one special. Kit remembered them all when constructing Hotel Emma, and his attention to detail earned it recognition not only as the best hotel in San Antonio but as one of the best in the state and the nation.

Many people think of visionaries as assertive and somewhat egotistical. Kit was neither. He was as comfortable in board rooms as he was with Mexican farm workers. In twenty years, I never heard Kit raise his voice, no matter the situation.

The transformation of the Mexican sauce category and the huge success of Pearl did not occur by accident. It occurred thanks to the vision and deter-mination of Mr. Kit Goldsbury, who was able to overcome much larger competi-tors in the Mexican sauce category, and who was able to see in Pearl a true destination that would make San Antonians proud.

BEER FIRST

Otto Koehler (b. 1855, Alfeld, Hanover Germany; d. 1914, San Antonio, Texas)
left Germany in 1872 headed for the United States, met and married
Emma Bentzen (b. 1858, St. Louis, Missouri; d. 1943, San Antonio Texas)
in 1882 in St. Louis, then headed for San Antonio, Texas in 1883 to help found
The San Antonio Bewing Company (*later San Antonio Brewing Association*)
operators of several breweries including a Breman-style lager called **"Pearl Beer"**.
Otto became president and manager of the San Antonio Brewing Associtation in 1902

Childless, the Koehler's adopted his neice and nephews and raised them as their own.
Anna Juliana Adelheide Hedwig "Hettie" Koethe (b. 1883, Hamelin, Germany; d. 1969, San Antonio),
who arrived in San Antonio in 1910, followed by her cousins **Otto A. Koehler** (b. 1893, d. 1970)
and **Charles Koehler** (who died in a hunting accident)

Otto A. Koehler joined the family beer business in 1921, and married
Marcia E. Marriner in 1922 who bore him a son.
Otto A. Koehler, Jr. (b. 1923, d. 1975)

Otto A. Koehler, took over at Pearl by the 1940s and changed the name from
The San Antonio Brewing Association to simply **PEARL BEER**.
Niether his son, nor his grandson, **Otto Koehler III**, carried on the tradition.
In 1985, Pearl bought Pabst Brewing Company and dropped the name Pearl.

THEN PICANTE SAUCE

Frank Bosshardt, son of a South Texas entrepreneur who owned, among his extensive holdings
the Ancira Hotel of Monterrey, Mexico where his mom helped cook with the aid of "salsa picante".
Frank married **Hedwig "Hettie" Koethe**, the adopted daughter of Otto and Emma Koehler in 1914.
Their daughter, Margaret Gretchen Emma ("Margo") Bosshardt (b. 1919, d. 2006)
married a Lousiana fellow, **David Earl Pace** (b. 1914, d. 1993).

Together with partners John and Sue Jockusch, they invented and promoted what would come to be

PACE PICANTE SAUCE

The Pace's had two children,
Linda Marie Pace (b. 1945, d. 2007) and **Paul Pace** (b. 1948).

Paul became a famous hand and wrist surgeon, while his sister became a patron
of the arts and married **Christopher "Kit" Goldsbury** (b. 1943) in 1967.

The Goldsbury's ran Pace Picante Sauce together until the couple divorced in 1991.

In the settlement, Kit Goldsbury became the sole owner of Pace Picante Sauce.
He sold it to Campbells in 1995, and used the proceeds to start
SILVER VENTURES and **THE GOLDSBURY FOUNDATION**.

In 2002, these enterprises bought the old Pearl and Lone Star Brewery buildings to create

THE PEARL DISTRICT

ACKNOWLEDGMENTS

Thanks to the following individuals who helped with the gathering of information—oral, documentary, and photographic—and who shared so many memories.

Rick, Ginger, and Annie Brendler Elizabeth Fauerso
Suzanne Mead Feldman Catherine Garcia
Michael Guarino and the staff of Ford, Powell & Carson, Architects
John Jockusch Paul Pace, MD
Morgan Exum Price Rodney Sands Tom Shelton
Patricia Galt Steves

The many journalists whose reporting provided creditable historic resources.

Otto Koehler I (1855-1914), *Kerville Mountain Times*, August 2, 1913. Zintgraff Studios, Z-1818E 1, UTSA Library Special Collections

CONTENTS

PEARL SETS THE PACE

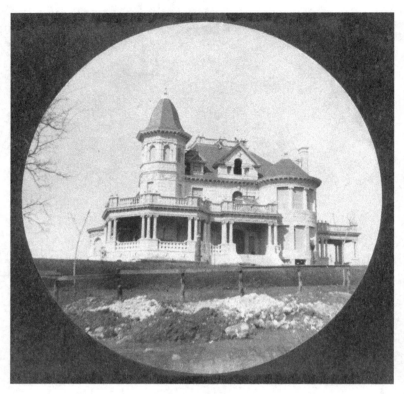

Otto Koehler residence. 310 West Ashby on Tobin Hill at the southern boundary of Laurel Heights Place in San Antonio, built 1901, designed by Carl von Seutter, 091-0311, UTSA Library Special Collections

Otto and Emma Koehler and the Pearl Brewery

O tto Koehler was born in Alfeld, Hanover, Germany, in 1855 and immi-
grated to the United States in 1872. In 1883 he came to San Antonio,
where he would become one of the organizers of what was first known as
the San Antonio Brewing Association, later the Pearl Brewing Company. He
became president of the company in 1902. The original recipe for Pearl Beer
used by the brewery had first been formulated and brewed in Bremen, Germany.
Its brewmaster thought the foamy bubbles in a freshly poured glass of beer
resembled sparkling pearls, hence the name Pearl.[1]

As an expression of his affluence in 1901, Otto Koehler built a grand, eclectic
Victorian mansion of 12,655 square feet at 310 West Ashby, with a bowling alley
in the basement and a ballroom on the top floor. One of the first residences in
the newly opened Laurel Heights section of town, Koehler built on a hill with
an unobstructed view of the brewery. Legend has it that while sitting on his
porch, he could determine whether his employees were hard at work by the
color of the smoke rising from the brewery's stacks.[2]

Otto and his wife Emma, who had no children of their own, first adopted
their niece, Anna Juliana Adelheid Hedwig Koethe, born in Hamelin, Germany.
After the death of her father, a physician, the family had fallen on hard times
and she arrived in Texas when she was just sixteen. Hedwig was soon joined by
her German cousins, Otto II and Charlie, who were also adopted by the Koehlers
in 1908 following the death of the first Otto's twin brother, Karl Koehler.[3]

Hedwig Koethe Bosshardt

Hedwig married lawyer Frank Bosshardt in 1914. It is significant to our picante
sauce story that Frank's family owned the Ancira Hotel in Monterrey, Mexico.
His mother, Anna Steiner Bosshardt, did most of the cooking for the hotel
and mastered the art of Mexican cuisine. From the time he spent helping run
the Ancira he acquired the nickname "Pancho." Their daughter and only child,

Margaret Emma Bosshardt, was born on December 9, 1919. Hedwig served on the board of the Pearl Brewery from 1943 until her death in 1969. Margaret would inherit from her mother not only her shares in the Pearl Brewery but her strong character and determination to overcome obstacles as well.[4]

The Murder of Otto Koehler: A Cautionary Tale of Three Emmas

Beer baron Otto Koehler was also the owner of the famous health resort, Hot Sulphur Wells in south San Antonio. He organized two mining operations and a rubber factory in Mexico, as well as serving as the president or director of fifteen different corporations. The shock of his murder in 1914 is still remembered a century later.[5] It was front-page news in papers from coast to coast, with provocative headlines the likes of "Millionaire Mysteriously Murdered by Pretty Nurse in Love Puzzle."

About 1910, Emma Koehler had been injured in an automobile accident and her husband hired a live-in nurse to look after her. Emma Dumpke, a petite brunette in her late twenties—Emma #2—accompanied the Koehlers on an extended tour of the healing spas of Europe. Upon the travelers' return home, Emma #2 described the intimate relations that existed between her and the

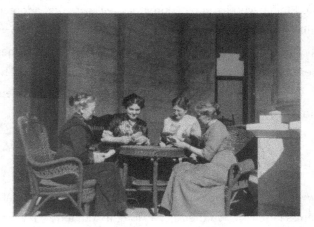

A gathering of relatives on the porch of the Koehler house early 1900s: Antonia Garrels, Hedwig Koethe, Emma Koehler and Elsie Garrels Lasker. Pace Family Collection, courtesy of Paul Pace, MD.

master of the house to her friend, a tall vivacious blonde named Emma Hedda Burgemeister—Emma #3—also a trained nurse.

At some point, Koehler bought Emma #2 a house on Hunstock Street near Roosevelt Park and also paid her living expenses. Emma #3 soon moved in and Otto deeded the house to both Emmas. When Emma #2 married a Mr. Daschel and set up housekeeping elsewhere, it was observed that Emma #3 received weekly evening visits from Otto over a period of several years. There are conflicting published versions of what brought him—in his horse and buggy—to Hunstock Street on November 12, 1914, at a little after four in the afternoon, but Emma #2 had returned to visit Emma #3 prior to his arrival. The complex reasons that he had come on that particular day were revealed in subsequent court proceedings, but within a few minutes of walking through the front door and straight to the bedroom of Emma #3, a quarrel erupted, and Emma #3 shot him dead with a .32 revolver.[6]

A grand jury no-billed Emma #2 but Emma #3 admitted guilt and was charged with murder.[7] She was arrested and was subsequently released on bail for a cash bond of $7,000. When her case was called the following February, it

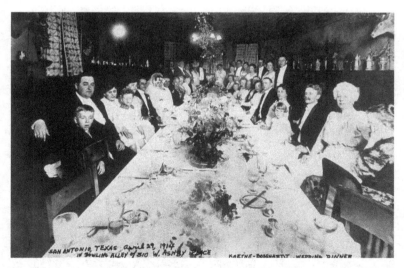

Wedding dinner in the bowling alley of the Koehler house following the marriage of Hedwig Koethe and Frank Bosshardt, April 29, 1914. Pace Family Collection, courtesy of Paul Pace, MD.

became known that she had jumped bail. The story was disseminated that she had decamped to Germany in order to tend the soldiers wounded in the World War that was raging. The bond was forfeited. It was discovered a year later that she had not gone to Europe after all but was living in New York City and wished to return and stand trial. While in the east in September of 1917, San Antonio District Attorney McAskill conferred with Emma #3 and her representatives and assured her that she would be given a fair trial.

The trial opened on January 14, 1918, to a courtroom packed with spectators. Former Texas governor T. M. Campbell (1907–1911) was the leading counsel for Miss Burgemeister, assisted by the firm of Chambers and Watson. (Considering the cost of such a distinguished legal team, it can only be surmised who might wish to bring closure to this tragedy.) A special venire was issued to summon 200 potential jurors, from which an all-male jury was selected.

A surprise headline read, "State's Witness Substantiates Defense Story." Mrs. Florence Ramer, a woman attorney and the storm center of the trial, testified that the lovers had become estranged and that Miss Burgemeister feared for her life. The attorney also stated that on the morning of the murder,

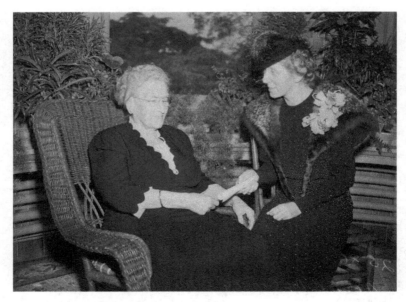

Emma Koehler with Mrs. B.B. McGimsey, ca. 1940.
ZintgraffStudios, 2-2586- E, UTSA Library Special Collections.

she prepared a codicil to the defendant's will because there were excellent grounds for thinking her end might be near and she wished to be prepared. The defendant also revealed that she was going to have a business meeting with Koehler at her house that evening concerning papers bearing Otto's signature, papers that he wished to retrieve—two notes for $10,000 each which were falling due. She reiterated that she feared for her life "at the hand of the man who signed these notes."

On the front page of the *San Antonio Light* for January 23, 1918, it was reported that "Burgemeister Jury's Verdict is Not Guilty: Wealthy Brewer Was Shot and Killed in House He Had Given Nurse." Innocent by virtue of self-defense. After the verdict, Emma #3 was surrounded by friends who showered their congratulations. As the jury filed by, she shook hands with each member of the jury, thanking them for their verdict.

In 1919, Emma #3 travelled to New Orleans where she married James Monroe Turley, a stockman by occupation who had been a member of the jury. The couple continued to live in the house on Hunstock for several years.[8]

The First Emma: The Ascendant Emma

In 1915, Emma Koehler donated eleven acres of land on the San Antonio River adjacent to Brackenridge Park and within walking distance of the zoo for a park in memory of her late husband. The gift came with the provision that the consumption of malt liquors be permitted there. When George W. Brackenridge gave 320 acres to the city for the park bearing his name in 1899, his gift prohibited the consumption of alcohol on park premises, however. To this day, the only place in the greater park where beer can be consumed is in Otto Koehler Park. The Koehler Pavilion was built under the Works Progress Administration in 1935–1937 and is a popular place for picnics.[9]

Emma: A Woman of Power in a Man's World

After the death of Otto, Emma assumed leadership of the brewery as chief executive, and by 1916 Pearl was the largest brewery in Texas.[10] During the thirteen years of Prohibition from 1920 until September 15, 1933, Emma

kept the company with its employees intact, working in league with Brooks McGimsey, brewery general manager, shareholder and the face of Pearl at most events. The only brewery in San Antonio to survive Prohibition, due in large part to their hard work and determination, Pearl produced "near beer," root beer and other bottled soft drinks, and entered the commercial ice and creamery businesses. They also operated an advertising sign company. When news of Prohibition's repeal finally reached the brewery, within fifteen minutes one hundred trucks and twenty-five boxcars loaded with Pearl Beer rolled out of the brewery grounds and down a street lined with cheering crowds.

Otto Koehler II: Line of Succession

After serving in World War I, Otto Koehler II became a Graduate Brewmaster and, in 1921, began his career assisting Emma at the Pearl Brewery.[11] His brother, Charlie, had died in a hunting accident. Emma and fellow board members selected Otto II as her successor, with Emma serving as Otto's advisor during the transition and in his first years as head of the brewery in the late 1930s. Coincidentally, several of Emma's heirs died around the same time as Emma's death in 1943. This left her adopted children, Hedwig and Otto, in control of the majority of shares in the Pearl Brewery.

Otto and his wife, Marcia, also assumed ownership of the spectacular estate on West Ashby. The Koehlers were active philanthropists and determined to deed the property to the San Antonio Union Junior College District (later the Alamo Community College District) adjacent to the San Antonio College campus for use as the Koehler Cultural Center. Following the death of Otto II in 1970, Marcia Koehler continued to live there until her death in 1981. She also established the Marcia and Otto Koehler Foundation for Arts, Culture, and Education.

Despite the Koehler family's successes, it was plagued by a series of grave tragedies and the line of succession was finally sundered in 1992. Almost three decades had passed since the death of the first Otto with its attendant tragedy and scandal, but from 1941 onward, evidence of the Koehler curse manifested itself in the lives of other family members. In February 1941, Mrs. Otto Koehler struck and killed an elderly man with her car near Selma, Texas.[12]

Her son fared even worse. A little less than a year later, in New Braunfels, Otto Koehler, Jr., driving drunk, killed his passenger, seventeen-year-old Louise Hill, in an early morning mishap. Koehler's vehicle jumped a curb and ended up in the town plaza. The girl, a popular student from a prominent San Antonio family, died instantly from a fractured skull. Koehler went to jail, posted bail, then joined the Army Air Corps shortly thereafter to put the incident behind him. After the war, he battled alcoholism and mental illness, his family finally committing him to an institution. In May 1975, Otto Koehler, Jr., died.

While the vehicle-related deaths involving Marcia Koehler and her son, Otto Jr., were tragic accidents, the nadir of the Koehler legend runs four generations deep in the family, whose name is still synonymous with Pearl Beer. In January 1992, forty-three-year-old Otto Koehler, III, was charged with the macabre murder of a woman said to be his mistress. The gruesome details were front page news. Like his father, he was afflicted with both substance abuse and mental illness. He had also been declared incompetent in 1989 to handle the trust his grandfather had established for him. He was released on $500,000 bond but landed back in jail two months later after threatening his sister, Marcia Koehler Hanson.

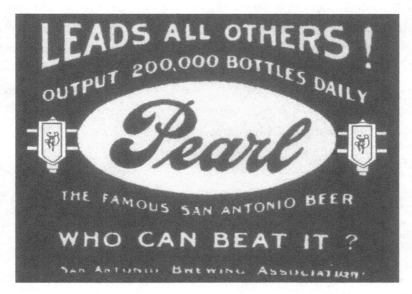

"Pearl Leads All Others". *Kerrville Mountain Times*, August 2, 1913

The state sought a murder conviction before the charge was reduced to voluntary manslaughter under a plea bargain. He spent twenty years in the penitentiary at Huntsville and then finished his probation in 2012, rehabilitated.

The Koehlers' era may have come to an end but their aura would live on in the memories of the students and faculty who were able to tour the property when it was first transferred to the community college and see it in its former grandeur. The ballroom on the top floor which had been transformed in the 1940s into a night club was unchanged—recalled the scenes of some of San Antonio's liveliest parties. A neon sign heralded the Zebra Room, decorated with a motif befitting its name, complete with a raised platform for the dance band, tables for four, cushioned seating in the turret overlooking the skyline, and a life-sized painting of a nude over the bar.

In the decade from 1981–1991, the mansion was primarily utilized by the art department of San Antonio College, notably as the area's leading contemporary arts gallery, which attracted large crowds for openings and other functions. In 1991, the new San Antonio College Visual Arts and Technology Building opened adjacent to the Koehler grounds. It featured ample exhibition and studio space, although the ceramics classes continue to utilize the Koehler's carriage house.

Today the offices of the Alamo Colleges Foundation are located in the house built by Otto and Emma Koehler. The philanthropic arm of the community college district, their mission is to fund scholarships, life-changing gifts that help students achieve their dreams of a college education. With its future assured, the Koehler residence forms an important part of the architectural heritage of Texas, a repurposed landmark with a fascinating history that will continue to enhance untold lives through future generations.

David Earl Pace

David Pace was born in 1914 near Monroe, Louisiana. His father ran a small business manufacturing cane syrup. After his parents' divorce, he was reared by his father. The absence of his mother caused him to have a strong distrust of women for the rest of his life. Nevertheless, Dave Pace was charmed by Margaret Bosshardt when they met in the summer of 1940, shortly after he finished the Army Air Corps flight school at Kelly Air Field. He intended to be a test pilot.1 Margaret was an art major at Sophie Newcomb College at Tulane University. Dave had graduated from Tulane with a double major in history and chemistry, where he had been a football star, playing tackle the first year Tulane played in the Sugar Bowl.

Dave and Margaret were married January 3, 1941. A grand reception was held at the Koehler residence on West Ashby. In February 1942, Dave was sent to India, where he was officer in charge of repairing and testing aircraft. On February 29, 1944, Dave returned from India and was almost immediately reassigned as officer in charge of flying safety in Winston-Salem, where he won acclaim for inventing a color-coded directional light system to orient night landings. He was joined there by Margaret. He would learn only several decades later that he had been kept away from the front lines—where he wanted to be—because of the German heritage of his mother-in-law.

Margaret Gretchen Emma Bosshardt Pace

Margaret's early childhood was shaped by the strong women around her. Aunt Emma, then widowed, was a guiding hand. The two spoke a combination of German and English. Margaret was fluent in both languages from the time she began to walk. Margaret's mother, Hedwig, was a powerful personality by anyone's definition. Early on, Margaret's interests focused on the arts. She attended Thomas Jefferson High School where her teachers offered

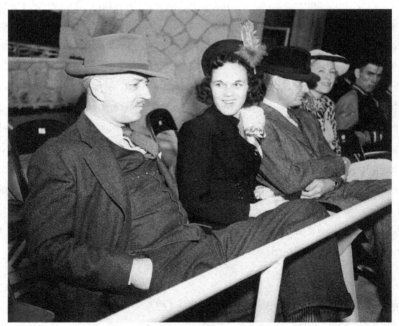

Top left: The Air Force had a rule that recently graduated cadets could not marry until after the new year. David Pace (left), November 1940. Pace Family Collection, courtesy of Paul Pace, MD. *Top right*: David Pace graduated from Air Force flight school as a second lieutenant in March 1940. Pace Family Collection, courtesy of Paul Pace, MD. *Bottom*: The war was raging in Europe, but Dave and Margaret were happily in love and became engaged. Otto Koehler II, Margaret Bosshardt, David Pace and Marcia Koehler at a football game in Alamo Stadium. L-2621-F *San Antonio Light*, 1940, UTSA Library Special Collections.

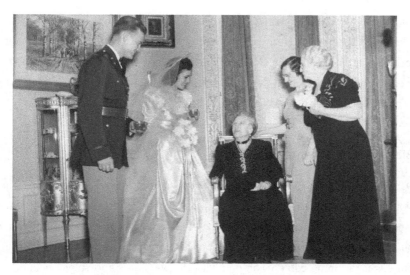

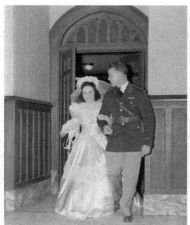

Top: The reception was held at the Koehler house on Ashby. The newlyweds greet Aunt Emma. The house was the ideal setting for such a large and festive gathering. Pace Family Collection, courtesy of Paul Pace, MD. *Bottom left*: Margaret and Dave were married on January 3, 1941 at the First Presbyterian Church in San Antonio. In keeping with military tradition when an officer marries, the couple walked under crossed swords. Pace Family Collection, courtesy of Paul Pace, MD. *Bottom right*: Another tradition observed. Pace Family Collection, courtesy of Paul Pace, MD.

encouragement and even lent her art books and included her in art-related events in their homes. Her early grounding in the arts stood her in good stead for a life as an advertising designer, art professor, and philanthropist, not to mention helping to design the elaborate gowns she wore during San Antonio's annual Fiesta Week as Fiesta Queen, riding on the Pearl Brewery float.

Birth of Pace Picante Sauce

David Pace aspired to become the head of an important business, but what would it be? With imagination, energy, his knowledge of chemistry—and faith in Margaret's access to Koehler funding—he set out to produce a product and build an empire.[2] During the latter half of 1945 he made imitation maple syrup, but sugar rationing came to an end with the war years and sales declined. In his search for a new product for which there would be a demand, he canvassed public opinion in grocery stores, restaurants and on the street. Margaret recalled that he came home one day and asked, "What is picante sauce?" Pace soon determined that there was a need for a consistent version of the "Mexican hot sauce" that was served in every Mexican restaurant, taco shop, and home throughout south Texas and northern Mexico. His guinea pigs were his friends at the neighborhood golf shop. He took variations of the original recipe for them to taste and criticize. Margaret shared a recipe that was a speciality of the Ancira Hotel—once owned by her father's family—an excellent variant of the hot sauces made daily from fresh ingredients and served with Mexican cuisine even in the humblest homes. The problem was how to make it safe to bottle and sell, as tomatoes and peppers tend to go bad quickly.

As 1945 rolled into 1946, Dave continued to sell jams and jellies out of the back of his truck by day. By night, the Paces made and bottled batches of picante sauce in their kitchen. The sound of lids pop-pop-popping off through the night signaled spoilage, and their quest would resume the next night. Dave set out to discover a way to preserve the picante sauce and still retain its fresh, uncooked flavor. His chemical and mechanical acumen were called into action. The chemistry department at the University of Texas at Austin allowed him the use of one of their laboratories and he spent long hours experimenting with

various formulae. The results were sealed in jars, labeled and arrayed on the kitchen shelves of the Pace family home. The trial-and-error period lasted some two years until Dave and Margaret finally discovered a method of preserving the fresh flavor of the jalapeños and other ingredients safely in their home test kitchen. At long last, the experiments had yielded the secret recipe that would become Pace Picante Sauce.

The next challenge was the design of the bottle that would contain Pace Picante Sauce. The resulting hourglass-shaped bottle that fits comfortably in the hand has since become part of the company's identity. Margaret exercised her artistic skills by designing a sunburst logo, inspired by the Missouri-Pacific logo she observed while waiting for a train to pass.

Taking the production line of Pace Picante Sauce out of their home kitchen was timely. Linda Marie Pace had been born April 17, 1945, while the couple was still living in Winston-Salem. The family story has it that Margaret sterilized Linda's baby bottles simultaneously with the picante sauce jars.

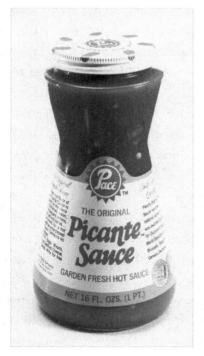

The Picante Sauce jar designed by Margaret Pace. Note the international gold medal (1971). Z-1749-11130, UTSA Library Special Collections.

They established their first "factory" in 1947 in the back room of a liquor store downtown behind Joske's Department Store, at 402 Water Street. The business, which was called "Pace's Pantry Prize" at that time, had until then manufactured jellies, jams and syrups. The two employees—Dave and Margaret—worked the line. The Paces filled the bottles, capped them, and put on the labels, all by hand.

A near calamity occurred when, just as the Paces were beginning to promote their picante sauce, the Joe Barcelona factory began producing its own "Tampico Sauce," the only similar condiment in the Mexican sauce market that both businesses were struggling to capture. That situation, coupled with the fact that the Paces were unable to obtain telephone service in their quarters behind Joske's, led Dave to purchase the Barcelona factory. It was located at 1015 Avenue A, just across the street from the famed Boehler Beer Garden on Josephine Street, and in the shadow of the Pearl Brewery. The Paces benefitted from the Barcelona factory being equipped for production on a larger scale, and from their expertise in various processes.

In 1948, friends John and Sue Jockusch became 49-percent partners in the business. John became the general sales manager, often traveling across the country to promote the brand. A feature article in the *San Antonio Express Magazine*, ca. 1949, titled "Pioneers in Peppers," celebrated the brand which was initially marketed as "Spanish Hot Sauce" as well as the "two young men with ideas ready to go places." A fellow artist, Sue Jockusch, joined Margaret in conducting recipe contests and other promotional endeavors. Margaret also designed point-of-purchase displays and drew a weekly Pace cartoon for the local newspapers. One of these cartoons, depicting a Mexican Santa Claus on horseback, backfired because it was considered demeaning to Hispanic people.

John Jockusch recalls that Dave would be at the farms that supplied his produce by 6:00 a.m. daily. Just as he had been interested in producing a product that would remain fresh-tasting when bottled, Dave became fascinated with cultivation of the ingredients themselves.

B.V. Hasselfield had begun breeding plants at the U.S. Experimental Station in Greenville, Texas, back in 1913 and became a state registered plant breeder in 1926. He believed that the jalapeño pepper would grow just as well or better on the Texas coast as it did in its native mountain valleys of Mexico. Thus he

 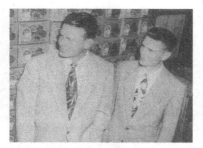

Top left: Celebration of the Pace - Jockusch partnership 1948-1950. Courtesy of John Jockusch. *Top right*: David Pace and John Jockusch, "two young men ready to go places." Courtesy of John Jockusch. *Below*: Sue Jockusch and Margaret Pace used their artistry to promote Pace Picante Sauce. Courtesy of John Jockusch.

began farming jalapeños in Tivoli, a small town on the Texas coast. A friend of Dave's who hunted on the farm in Tivoli returned to San Antonio with a load of beautiful jalapeño peppers. Pace, who had never seen such perfect specimens in Texas, immediately bought the entire crop and established Hasselfield as a supplier.

Dave soon convinced farmers in closer proximity to San Antonio to grow Hasselfield's breed of jalapeño peppers—a crop new to the area—as well as onions, tomatoes, and other needed ingredients. One of the first was Van De Walle Farms, just north of Lackland Air Force Base. Eventually, as the business grew, farmers were contracted to grow jalapeños from New Mexico to old

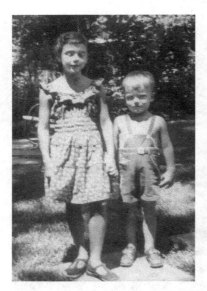 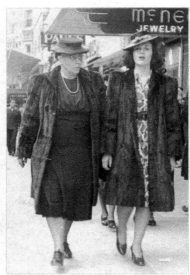

Left: Big sister, Linda, with brother, Paul Pace. Pace Family Collection, courtesy of Paul Pace, MD. **Right**: A street photographer captures Hedwig Koethe Bosshardt and her daughter, Margaret Pace, on Houston Street. Pace Family Collection, courtesy of Paul Pace, MD.

Mexico. This insured the availability of fresh jalapeños at all times during the year. Another of Dave's innovations was the introduction of bees into the fields to help pollinate the crops.

This was a busy and exciting time for the Pace family with the uncertainty of beginning of a new business and a growing family. Their second child, Paul David Pace, was born on August 31, 1948.

Profitable but short-lived, the Pace-Jockusch partnership was amicably dissolved in 1950. That year, John joined the investment firm Dittmar & Co. (now Morgan Stanley) where he worked for the next 60 years, only retiring at the age of 93.

In 1956, Margaret's mother, Hedwig, financed the building of a new plant at 1414 North San Jacinto Street, listed in the City Directory that year as the Pace-Koehler Pickles Company. Having the secret recipe for Pace Picante Sauce and developing that one product was not enough for Dave. He bought loss leader products which he believed would boost sales of the main product. The company would finally make a modest profit and then Dave would buy another

company, funded either by Margaret's Pearl stock income or with Hedwig's money. The curious alternate name of the company is explained by Dave's purchase of a pickle factory in Somerset that had fifty-five cypress barrels for curing pickles. In all, Dave Pace produced some fifty-eight different products. Beside maple syrup and picante sauce, he tried to produce preserves, mayonnaise, salad dressing, and chili con carne seasoning mix.

Dave was a tinkerer and a creator. He enjoyed going through the cast off machinery at the brewery just to see if he could adapt it to his needs. He was very intelligent, scientific, and enthusiastic, but he was rather impractical about carrying things through to completion. In the struggle to remain financially solvent, Margaret once even resorted to selling some of her Pearl stock to pay for a load of tomatoes when there was no money in the bank. As generous as Hedwig had been, inevitably there came a time when she would no longer "lend" money for Dave's many product ventures, forcing the Paces to apply for bank loans. It also became apparent that Dave was powerless to control his growing addiction to alcohol. He began attending Alcoholics Anonymous, but was unable to stick with the program for more than a few months.

In spite of familial discord and the cultural upheaval that the decade would bring, the 1960s would be a good fit for Pace Picante Sauce.

Pace Picante Sauce's burgeoning success encouraged Dave and Margaret to consolidate their line and concentrate on a single item—and it was not among the syrups and jams that Dave had included in Pace's Pantry Prize line! They realized that the "real syrup" of San Antonio was not maple but picante— Spanish for "piquant," or "spicy and flavorful." Until 1965, Pace Picante Sauce had been marketed solely as a Mexican hot sauce.[1] But that year Pace Foods changed their strategy and began to market Pace Picante Sauce as a condiment rather than a specialty item; that is, something used to give special flavor or seasoning to food—any food, not just Mexican food.

The demographics of the United States were changing, and the nation's taste changed, too. While the country was caught up in a swirl of change—protests, political unrest, the Civil Rights movement, the Anti-War movements, and the rise of a significant counterculture—the spirit of revolution extended to the nation's palate as well. It was not just a few hippies who had discovered that "you are what you eat." If the counterculture of that era was truly successful in raising America's consciousness about anything, it was about food and health. It became important to respect one's body, and that started with the foods that one consumed.

Demand began to grow for unadulterated natural foods, preferably locally sourced. (It didn't hurt that a dash of the piquant can make many such foods more palatable!) In addition, many people grew distrustful of the additives and preservatives that were common in processed foods and noted that Pace Picante Sauce was free of these noxious substances. Horizons were broadened to include traditional ethnic foods, including Mexican or Tex-Mex and southwestern flavors. The fresh-tasting Mexican sauce would eliminate the tedious daily chore of preparing homemade picante sauce. The Paces' timing was propitious.

The secret of their continued success was that only the freshest jalapeños would be used all year long. While other pepper sauce manufacturers might use canned or brined peppers when winter freezes wiped out their crops, the Paces never compromised, a fact that did not escape the notice of consumers.

As the American diet became more health conscious in the 1960s and horizons broadened to include traditional ethnic foods, the Paces' timing was propitious. 1966 photograph. Z-1749-55399, UTSA Library Special Collections.

Originally, in the 1950s, the Paces bought their peppers from local or regional farms. Dave—ever the farmer at heart—even convinced Margaret that they should move to the country and grow the needed peppers on an eighteen-acre farm north of San Antonio. Their children loved it; Margaret did not. Alas, things on the farm went from bad to worse. A drought caused crop failure. The water well went dry. The butane stove in the house exploded and the deer were so fond of the peppers that Dave had difficulty maintaining a supply. After three and a half years of an unbearable situation, Dave agreed to move back to town to a lovely house on Morningside Drive in the township of Terrell

Hills. In meeting the challenge of providing fresh jalapeños year round in ever-increasing quantities, the Pace organization as it evolved through the decades followed the sun and harvests in search of the highest quality fresh peppers—from southern Mexico north to Texas, New Mexico, California and Florida. Mexico has some of the richest agricultural areas in the world, and it is not unusual for farmers there to grow three crops a year in a single field. The soil in these fields is so rich that fence posts root and sprout leaves.[2] This fertile soil, along with the perfect combination of warmth and rainfall, yields some of the best jalapeños that can be grown—flavorful, meaty, and thick-walled.

It became the expected practice that the fresh-picked peppers were refrigerated from the time they were harvested until they arrived at the Pace plant in San Antonio. The process is known as cold chain. There they were kept in cool storage until ready for use, often in as short a time as three days. Ultimately, the Pace brand developed its own pepper seeds. By 1995, more than twenty-five million pounds of jalapeños were used annually in Pace Picante Sauce.

With traditional Mexican or Tex-Mex and southwestern flavors gaining favor from the 1960s on, as well as the secret means Dave discovered to preserve the picante sauce while retaining its fresh uncooked flavor, the future of Pace Foods looked promising. But with his intensely enthusiastic nature, Dave sought more immediate challenges. He suffered from a bad back and was determined to make a more comfortable office chair for businessmen. Its unique quality was that it could go from upright to reclining in seconds. He patented his invention in 1967. At one time George Nelson, the celebrated designer for the Herman Miller Company, offered to buy the design so that it could be put into production as a hospital guest chair, an offer Dave rejected even though it would have helped get the family out of debt. He wanted to develop and market the chair himself.

For three years, from 1969 to 1972, Lon Carpenter called on the Pace Foods plant on San Jacinto to encourage Dave to do business with Frost Bank. He failed in these efforts but the encounters were revealing. As the representative of a venerable institution, Lon received a cordial welcome from other prospects but Dave was an exception. He was a character who never smiled, and yet he was gracious in his gruffness. A visit to the production line and presentation of samples of the product were features of these brief encounters, but Dave had no interest in discussing the business or its expansion. What he *was* interested in discussing was his ergonomic chair that he had prominently displayed in the office. Always pointing out his most recent improvements, he suggested that Frost Bank might be interested in financing production of the chair.

To allay concerns about continued financial insecurity and to provide for the future of their children, Margaret took a position as instructor of design and art history at San Antonio College in the fall of 1961. She was successful in her job and felt her sense of independence and worth returning. She also began taking courses that would lead to a second degree in architecture. Margaret was in the vanguard of her circle of women friends entering the work force.

While this would have been threatening to most men of his generation, there were compensations. In 1966, Dave found a like-minded spirit in sculptor

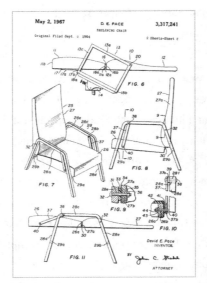
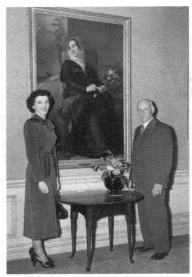

Left: Patent drawing #2 for reclining chair, 1967, D. E. Pace, inventor. Pace Family Collection, courtesy of Paul Pace, MD. *Right*: Margaret Pace and Dr. Frederick Oppenheimer, board chairman of the Witte Museum, at the opening and dedication of the Emma Koehler Memorial Gallery of Early American Art. Pace Family Collection, courtesy of Paul Pace, MD.

Mark Pritchett, a recent Master of Fine Arts graduate. Mark was stationed at Lackland AFB and served as a medical illustrator at Wilford Hall Hospital. He also taught part-time in the art department at SAC and shared an office with Margaret.

After their regular working day, Mark and Dave discussed ideas about office furniture and other design matters at the Pace factory, then at 1414 North San Jacinto. Mark welcomed the opportunity to be involved with design as well as the modest salary. As part of the design process, Dave made prototypes of his furniture ideas. In one of his scavenger hunts through discarded materials at the Pearl Brewery, he discovered a stack of aged cypress planks twenty-five feet long, five inches thick, and twenty-four inches wide in perfect condition, formerly used as vats in the brewing process. These were recycled by the Pace-Pritchett team to build several work tables for their projected studio. That the studio with dusty furniture fabrication occupied the same factory space as the picante sauce production line was a problem, one which Dave solved by building a surrounding partition. By and by, the chair project was set aside,

but not forgotten. It would be resurrected almost two decades later. In the meantime, Dave and Mark also researched the re-design of the picante sauce bottle, working in collaboration with the glass fabricators in Houston. The bottle shape is still used today.

Margaret must have been reassured concerning her children's future as she watched them follow in her footsteps. In 1963, Linda graduated from St. Mary's Hall, an Episcopalian girls school. A born leader, she was captain of one of the school's intramural teams in her senior year. The combined birthday celebration of Linda at eighteen and her grandmother, Hedwig, at eighty was another big event that year. That same year, Linda first dated Christopher Goldsbury, known to all as Kit, who was attending Menlo College in Menlo Park, California.

After taking Linda home following the Christmas dance at her school, Kit was in an automobile accident and suffered a broken neck. Linda visited him daily in the hospital and fell in love. Even so, the romance was on-again, off-again while Linda was in college.

Linda attended Southern Methodist University in Dallas as an art major for two years. She then transferred to the University of Texas at Austin in her junior year. There she received a devastating rejection of her potential as an artist from one of her professors and returned home. Kit had graduated from Trinity University with a degree in political science in 1966 and was ready to settle down.

Kit and Linda were married on June 16, 1967, in a large wedding at St. Luke's Episcopal Church—with a reception for 500 guests at the San Antonio Country Club—followed by their honeymoon in Mexico. Kit's mother, Margaret Barclay Goldsbury, known as "Monnie," was from a prominent South Texas ranching and banking family. In 1940, she reigned as San Antonio Fiesta "Queen of the Court of the Old South," the theme chosen by the Order of the Alamo for her coronation, inspired by the book *Gone with the Wind*. His father was an insurance executive.

Linda knew exactly what her mother expected of her. "She wanted me to be a lady, get married, have children, take my place in her social world, and find time to figure out a way to 'do art' on the side." Linda opined that this was the way her mother lived her life.[1] As Margaret encouraged Linda along

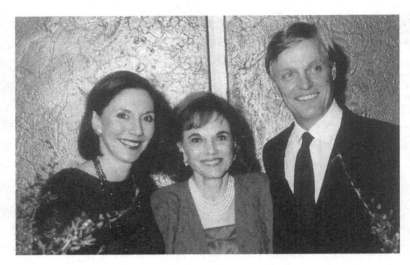

Margaret with her" dreams come true," artist Linda and physician Paul Pace.
Pace Family Collection, courtesy of Paul Pace, MD.

a conventional female path at the time, she urged Paul on a traditional male path. Early on, Paul aspired to be a physician and Margaret did all in her power to make his dream a reality. After graduation from Southern Methodist University, he earned his medical degree with highest honors in surgery from Tulane and established a successful practice as a hand surgeon in San Antonio.

Two children would complete the Goldsbury family. Margaret Marie, nicknamed "Mardie," was born on September 22, 1968. Their son, Chris, was born on April 26, 1972. They would soon be living a few blocks from Dave and Margaret on Morningside, a seemingly perfect family.

Kit worked early on in their marriage in his father's insurance business.[2] But as a young man just starting out in the world, he wanted to do something more vital, more alive. The Pace company had made its first profit in 1968, two decades after its founding—about $30,000. The following year, in 1969, Kit jumped at the chance to join Pace Foods at Dave's invitation.

Margaret's mother, Anna Hedwig Koethe Bosshardt, died that same year. She had served capably on the board of the Pearl Brewery following in her Aunt Emma Koehler's footsteps as a woman of power in a man's world. She gave generously and from day one had helped to ensure that Pace Foods thrived. It was the end of an era and the beginning of a new one.

David Pace, then fifty-five, was a task master and required his son-in-law to start on the production line sorting vegetables. Kit accepted that he must learn the business from the bottom up, even though the smell of onions and peppers aggravated his severe allergies.[1] He continued working on the line for six months before being allowed to enter sales—where he proved to be a natural. He had grown up eating chilis, hot sauce, and peppers at the family ranch in Mexico, thus acquiring a discriminating palate for traditional flavors. He quickly learned the business, had an easygoing personality, and was fluent in Spanish. If a store or distributor had doubts about buying a product made in San Antonio, Texas, talking to Kit changed their minds.

Though busy caring for the children, Linda figured out a way to "do art on the side," as had her mother. In Louis Lubberinger, a professor in the art department of Trinity University, she found a mentor who restored her confidence as an artist. She earned her art degree from Trinity in 1980, almost two decades after entering SMU. She would be the next in this line of strong, determined women.

Kit represented Pace Foods at trade shows and after a few years, Linda often accompanied him. *The Pace Picante Cookbook* was one of the product ideas they developed as a team, reminiscent of the recipe contests staged by her mother and Sue Jockusch in the late 1940s. Each page was in the form of a recipe card, with some "comfort food" standards but also including new gourmet offerings. Foldout brochures were displayed at the point of purchase.

With the encouragement of Jack Mays, a Dallas broker, Kit convinced Dave to think internationally. With U.S. military personnel stationed around the world, all of whom were hungry for the taste of home, Pace Picante Sauce would henceforth be available at base commissaries. The brand also gained prestige by winning gold medals in domestic competitions as well as internationally in Belgium, Switzerland, and Luxembourg.

Kit was the fair-haired boy and as the Pace business began to grow, Dave began to feel threatened. He often advised his son-in-law to "go slow and keep it simple." To assert his authority, he was known to have verbally abused Kit

and other employees, which created a management stalemate. The situation was made worse by his drinking problem which he tried, unsuccessfully, to overcome with the help of his AA sponsor, Jim Cullum, Sr., and Rev. Joe Brown, minister at St. Luke's Episcopal Church. To further complicate matters, Dave moved out of his office at the Pace facilities to a building at 247 West Olmos Drive.[2]

After a long and conflicted marriage, Dave and Margaret were finally divorced in 1976. While the divorce was difficult for both, Margaret was devastated and, given the time period, ashamed that her marriage had failed. She was determined that Pace Foods would not suffer for it. They still owned the business together and their power struggle was intense and occasionally quite public. Dave's hand-picked board of directors were his friends, all with the mindset that a woman was not competent to run a business. The "good old boy" system was still alive and well. The struggle lasted until January 1979, when Margaret purchased Dave's half of Pace Foods for two million dollars.

While Dave may have been lacking in business acumen, he had a gift for friendship across generational lines. The Paces and the Eugene Ames families had long been friends. In the unsettled times of the early 1980s, Dave and their son, Gene Ames, would meet several times a week in the late afternoon for nine holes of golf at the San Antonio Country Club.[3] Walking—rather than riding in a cart—while conversing on all manner of subjects, Gene remembered that Dave neither tried to justify himself nor was he one to carry a grudge. Rather, with his scientific intellect, he seemed at peace with letting go of the company. In fact, he now had the means and the time for his work long in progress, the development of the reclining executive chair. His office on West Olmos Drive was converted into the Pace Chair Company's plant, with a small assembly line for manufacture of the chairs. Architect James "Bert" Elbert Whiteaker, like Dave an active member of St. Luke's Episcopal Church, worked closely on improvements to the chair, including the resolution of structural problems. (Whiteaker had previously been president of the Beautify San Antonio Association.) A few years later, in an article by Veronica Salazar in the *San Antonio Express-News* of September 28, 1986, Dave is quoted: "The Pace chair is a whole new concept in seating for a dual purpose—comfort and health. It is orthopedically designed and constructed to support the spine and

lower lumbar regions. A change in angle eliminates pressure points in the seat."
He further noted that the chair was then being manufactured in Alabama. But
the outcome was not positive. The cost of the few chairs that were produced
was prohibitive, as were the shipping costs.

Now chairman of the board and sole owner of Pace Picante, Inc., Margaret
immediately named Kit Goldsbury as president. Daughter Linda was elected
to the board and was named secretary. Prior to the buy-out, Margaret had
been thrown out of a meeting of the board when she spoke up for Kit as Dave's
successor. The board had considered him too young to run the company and,
prior to Margaret's acquisition, that promoting him would represent a betrayal
of Dave.

In effect, Kit was now working for Margaret. Although they had previously
been allies, they were inevitably at loggerheads. But Margaret did, at last,
find happiness with her marriage, on May 30, 1981, to a highly-regarded glass
sculptor, Robert Willson, as would Dave with his marriage to the former Jean
Overland in 1986.[4]

Margaret was satisfied that the company was on a firm footing after two years as owner of Pace Picante, Inc., and agreed to sell the company to Kit and Linda.

Negotiations went back and forth until a price of $14 million was agreed upon in September of 1982. Margaret and Robert Willson made annual extended stays in Venice, where Robert worked with the glass masters on the island suburb of Murano and Margaret found inspiration for her paintings, which was surely also a consideration for the trips.

The Goldsburys mortgaged all their possessions to buy the company and were "scared to death." But they were a team and this is what they wanted to do. Although Linda did not have day-to-day responsibility for the company, she continued to accompany Kit on sales trips, setting up food booths and handing out samples of the product. Decisions were also weighed jointly.

Early on at Kit's suggestion, Pat McDonough was hired as a consultant. He had been instrumental in the promotion of Gillette razor blades, Black & Decker, and other gold star companies. Retired from successfully running his own business, he only agreed to work for companies that he was confident had great potential. He came to San Antonio two days a month and was instrumental in devising a strategic plan for growth that included hiring specialists in finance and marketing. Rod Sands would join the company in August of 1982 as vice president of sales and marketing. At the time of his arrival, Quaker Oats held the rights to market and sell Pace Foods products to the food service industry. This was a very profitable arrangement for Quaker and it took a couple of years for Pace to reclaim this role. For Quaker, it was also the means of nurturing a relationship which might enhance their opportunity to acquire Pace. (More than a decade later, Quaker was one of many companies given the chance to bid for Pace Foods but fell out of the bidding process early on.) Sands would become Chief Operating Officer seven years late, and President in 1992. It was a perfect match. He developed the Pace 25 Club, an organization that would support four regional inner-city schools in San Antonio with more than $100,000 annually.

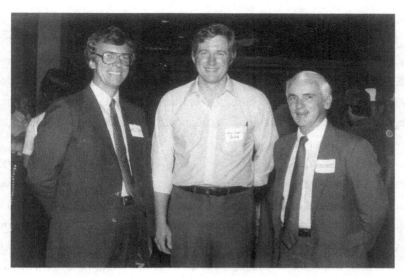

Soon after Kit and Linda Goldsbury became owners of Pace Picante, Inc. in1982, Rodney Sands joined the company as vice president of sales and marketing (chief operating officer seven years later and president in 1992.) Rodney Sands, center, with Quaker Oats executives. Photograph courtesy of Rodney Sands.

McDonough was a dynamic motivator; each month he assigned each department head an area to research and report the findings upon his return. He made his clients believe that they had come up with their own solutions—a seemingly unseen force. Operations of the company improved dramatically. New warehouses were added to the distribution area and annual sales increased over previous years many times over. The services of Bozell & Jacobs, a Dallas advertising firm, were engaged to launch a television campaign, including the now-famous commercial featuring three classic Texas cowboy-codger types who remark on where their picante sauce was made. One cowboy, reading the back of his brand, yelled out in disgust, "Ne-e-ew York City! Get a rope." The second cowboy held up a bottle of Pace Picante Sauce and said "made in San Antonio, Texas, where folks know what picante sauce should taste like." The commercial put Pace Picante and San Antonio on the map and created a nationwide market for salsa.

Kit's commitment to a progressive management policy was another con-tributing factor to the success of the business. A journalist observed that "Goldsbury sounds like a proud papa when talking about company and

employee relations." He made everyone who worked with the company feel as if they were one big family and, as such, owners of the product, "the best hot sauce in the world."[1] Employees, who were referred to as "associates," were treated with respect, honored for their input in the team effort and rewarded by incentive programs. That company meetings were held in both Spanish and English, and all printed materials were printed in both languages, enhanced the spirit of collegiality.

By 1982, Pace Foods also launched a new Taco sauce. This return to diversification reflected Goldsbury's aim to develop a quality company with small specialties. The business which was bursting at the seams was still located in the plant at 1414 North San Jacinto Street which had been financed by Margaret Pace's mother, Hedwig Bosshardt, a quarter century earlier in 1956.

The time had come. It was announced in the press that Pace Foods would build a state-of-the-art 50,000 square foot facility on a seven and a half acre site on the east bank of Salado Creek at 3750 Interstate 35 North.[2] The firm of Ford, Powell & Carson, Architects and Planners, received the appointment with

On a site beautifully transformed into a park-like setting overlooking historic Salado Creek, the manufacturing plant was revolutionary. Pace broke the boundaries between management and labor . . . one functional entity of art-light-space. It was a reflection of the Goldsburys' philosophy about the company. All who worked there were regarded as one big family. Photographs 23 -29, courtesy of Ford Powell and Carson, Architects. Chris Carson, Principal-in-charge with Joe Castorena.

Chris Carson, principal-in-charge, and Joe Castorena. The contractors were Guido Brothers Construction Company. Friendship between the architect and his clients was long standing.

During their first meetings about the project, the aspirations expressed immediately brought to the architect's mind the concept of the Texas Instruments Semiconductor Building, designed by O'Neil Ford and Richard Colley in the mid-fifties. Patrick Haggerty, the young president of the company, wanted a humane working environment that broke down the barriers between management and the workers. It was a perfect match.[3]

The phrase "state-of-the-art" referenced the aesthetics of architecture and humanitarian as well as environmental considerations and was no mere hype. On what had been a trash-filled lot would rise a building that would reflect South Texas regionalism. The stucco, plaster, and pre-cast concrete structure in earth tones featured a series of landscaped courtyards and large glazed openings. In the production area the size of a basketball court, skylight monitors would provide natural lighting and baffle heating loads to conserve energy while operable windows would bring fresh air into the building. The wooded Salado Creek could be viewed from both the production line and

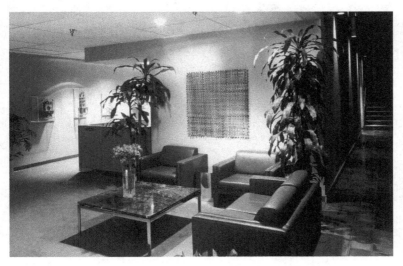

Main lobby. As most employees had family ties to Mexico, the art-mostly hand-crafted folk art-displayed respect for their culture. Courtesy of Ford Powell and Carson, Architects.

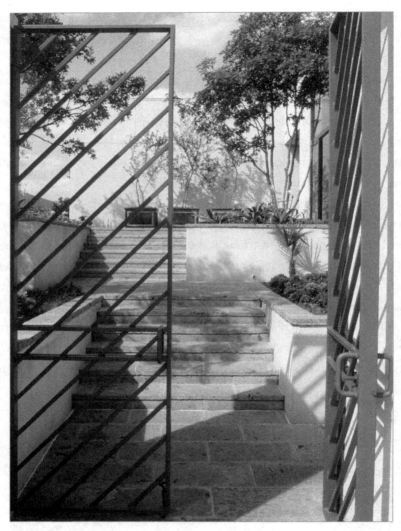

Above: Main entrance. Modulation of spaces through gates which were a reflection of O'Neil Ford's preferred use of diagonals -motifs first admired in vernacular architecture of the Rio Grande borderlands. Note the planters crafted by Lynn Ford. Courtesy of Ford Powell and Carson, Architects. *Opposite page, top*: The breakroom, which was shared by management and employees, had natural light and a view to vistas beyond. Courtesy of Ford Powell and Carson, Architects. *Opposite page, middle*: Modular workstations. Courtesy of Ford Powell and Carson, Architects. *Opposite page, bottom*: Collection of whimsical folk art. Courtesy of Ford Powell and Carson, Architects.

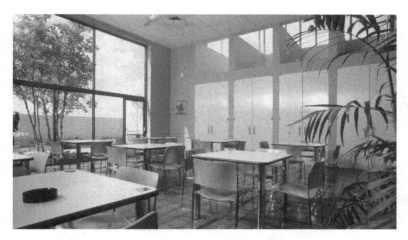

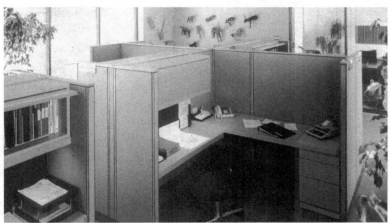

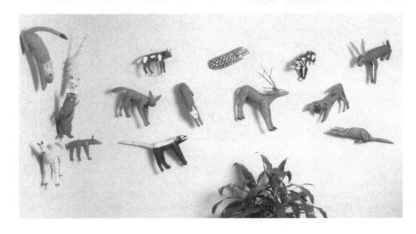

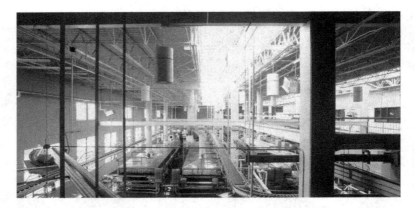

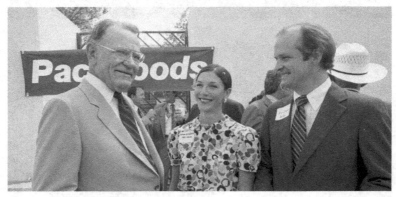

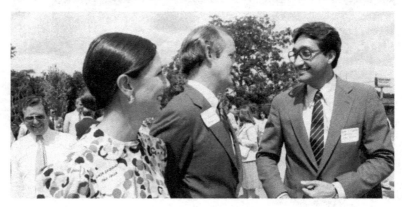

Top: Plant production line. Fresh air moved through the space illuminated by indirect light with a view of Salado Creek. The climate control systems, which were permeated with jalapeño fumes had to be replaced by the subsequent owner. Courtesy of Ford Powell and Carson, Architects. *Middle*: David Pace with Linda and Kit Goldsbury at the opening of the new Pace plant. E-0173-065 -21, UTSA Library Special Collections. *Bottom*: The Goldsburys welcome Henry Cisneros, Mayor of San Antonio. E-0173-065-26, UTSA Library Special Collections.

administrative offices. Offices and production line personnel also shared a common break room which further served to bond management and the associates. Mexican folk art and Southwestern collections would be displayed throughout.

The phrase "state-of-the-art" also referenced the technology of food production. With a new facility five times larger than the existing plant, the company would quadruple its production capacity of nationally distributed products. A complete laboratory for product testing, quality control, and new product development would include equipment which would allow the company to add products as they advanced beyond the research phase.

The new plant was formally unveiled on August 4, 1983, in appropriate fashion. Hundreds of guests were served margaritas in Picante Sauce jars. Over the years, Pace Picante would add to San Antonio's almost mystical association with Mexican culture and cuisine. Travelers passing along Interstate 35 still remember the delicious smells of onions and jalapeños emanating from the handsome building.[4]

When Kit Goldsbury, then in his mid-thirties, became president of Pace Foods in January of 1979, the product was spread throughout markets primarily in the Southwest.[1] The big diversified food companies, however, began to pay attention, and in the 1980s the competition intensified. Chesebrough Ponds, the first large company to enter the fray, launched Montera, a line of Mexican sauces that included picante. St. Louis-based Pet Incorporated's established Old El Paso brand, with twenty-five percent of the market nationwide, was soon challenged by Pace. As it climbed to the top of the salsa world, Pace Foods fought successfully against rivals in what became known as "the picante wars." In October of 1986, Pace filed a federal lawsuit charging its then chief rival, Old El Paso, with trademark infringement by having labeling colors and a product jar similar to Pace's familiar hourglass-shaped bottle. The case was settled in January 1988 when Old El Paso agreed to change its bottle shape and label design.[2]

Goldsbury determined that Pace, which had operated for more than thirty years in the classic "Mom and Pop" mode was not going to be crowded out of its own market. To fight the big food companies, Goldsbury enlisted help from among their ranks. Specialists from companies such as Uncle Ben's Rice, Miller Brewing Company, Pepsi-Cola/Frito-Lay, Church's Chicken, and Hershey's Chocolate were offered compelling incentives to join the Pace Picante team. In advance of the new plant opening, Goldsbury hired Dr. Lou Rasplicka as Vice President of Technology in 1982. With a doctorate in food science from Washington State University, he had previously been with Church's Chicken.[3] He was brought on board to mastermind the food science laboratory and would be nicknamed "Dr. Pepper." A former president of the Texas Pepper Foundation, he used liquid gas chromatography to determine the capsicum levels in parts per million of each incoming batch of jalapeños. Because chilis of the same variety can vary widely in heat depending on many factors—soil, weather, ripeness, transit time—testing is essential. David Pace's original sauce compares to what is now "medium," or between eight and ten parts per million.

Lou Rasplicka, Ph.D. known as "Dr. Pepper," was brought on board by Kit Goldsbury to master-mind the food science laboratory. Photograph from the collection of Dr. Lou Rasplicka, courtesy of Annie, Ginger and Rick Brendler.

One of Rasplicka's significant achievements was his role in hybridizing the no-heat jalapeño, desirable due to its lack of pungency as well as methods for the production of food products comprising low capsaicinoid content. (The new distinct and stable cultivars of no-heat jalapeño peppers were awarded United States Patent 5959186, publication date 09-28-1999; inventors Lou Rasplicka, Don Arevalos and Phil Villa.) In a secluded hydroponic greenhouse on a test farm in Quihi near Castroville in a period of over four years, Rasplicka had conducted experiments in selective breeding to come up with the no-heat jalapeño chili. Test plots were planted all over the contiguous U.S. states and Hawaii to grow the chili plants in areas far from other chili production to insure that cross-pollination would not occur.

Kit Goldsbury and Dr. Rasplicka with growers in Papantla, Veracruz, Mexico. Photograph from the collection of Dr. Lou Rasplicka, courtesy of Annie, Ginger and Rick Brendler.

The key to Pace's consistency was and is the no-heat jalapeño. Rasplicka explained that when a particularly spicy batch of chilis came in and was measured, it could quickly be determined through a single formula how much of the no-heat chili to add so that the salsa had the correctly balanced heat level and proper jalapeño flavor level.

The company's expansion took off when the freshness of the product was extolled in a full scale marketing campaign on television, radio, and in print media. The story of the company's "farm teams" that worked directly with growers along the 2,000 miles of the jalapeño trail, which led as far south as the states of Oaxaca and Veracruz, was surely exceptional—as was Goldsbury's hands-on agricultural approach which derived from his youthful experience on the family ranch in Mexico.[4]

Keeping in touch with customers was another ingredient that kept Pace hot.

Pace's extra mild product came about because of complaints that "mild" was too hot. Customers nationwide could dial the toll-free number listed on the Pace jar and speak to one of four women who exclusively answered these calls—a "hot line" that lived up to its name.

In order to meet growing demand in all fifty states, Pace had more than 480 associates employed at the new plant. Scheduled on a four-day work week, the production line operated around the clock. By 1986, Pace was producing

250,000 pounds of Picante Sauce daily, using more than thirty million pounds of jalapeños annually.

Pace also began selling its picante sauce in Monterrey as a pilot project prior to a nationwide marketing effort in Mexico. Sold under the label "Salsa con Jalapeño," the product was the same. In its advertising in Mexico, Pace chose not to imitate the U.S. campaign but rather pitched the salsa to homemakers who traditionally made salsa for the family table every day.

Since 1974, the Texas Food Processors Association has paid tribute to excellence by recognizing those individuals who have made major contributions to the food industry in Texas with one recipient named annually. In 1990, David Pace was so acknowledged, as was Lou Rasplicka in 1998.

Although the company was booming, dark clouds were gathering in the Goldsbury household. Business demands put a strain on the marriage and their children, who were in their late teens, were beset by drug experimentation and other generational perplexities.[1] To their close circle of friends Kit and Linda seemed to have a solid marriage, but there were many marital failures within the group. These were due, at least in part, to the options espoused by the women's liberation movement. The feminist anthem, Helen Reddy's song, "I Am Woman," said it all.

In 1988, Kit and Linda separated and Linda filed for divorce. As a result of the settlement, finalized in 1991, Kit became the sole owner of Pace Foods. Linda sold her fifty-percent share to Kit for $95 million. The details of the divorce and the division of Pace Foods was resolved with a minimum of hostility.

In her book *Dreaming Red*, Linda describes her desire to reclaim her career as an artist and also determine how to marshal her financial resources in order to make a contribution to the arts in San Antonio.

The San Antonio Art Institute provided the focus for these interrelated commitments. Founded as a community school for artists, Marion Koogler McNay in 1942 provided a needed home for the school in what had been the aviary of her Sunset Hills mansion.[2] Linda's development as both artist and art philanthropist had begun in 1989 when she was both student at the Institute and a member of the its Board of Trustees. She was elected board chair in 1991. The decision had been made early in the 1980s when the economy was booming to elevate the institute to a college offering an accredited Bachelor of Fine Arts degree. However, by the end of the decade, the price of oil dropped, plunging Texas into a recession. While many pledges never materialized, Linda made a substantial contribution as did her mother, Margaret, and other board members.[3]

In an analysis by art critic Dan R. Goddard of the demise of the San Antonio Art Institute, commissioned by the Southwest School of Art in 2010, Linda's efforts to save her beloved school were prodigious. Her oft-quoted memoranda

to the trustees are a prime source. Four primary problems were cited: enroll-
ment projections were over-estimated; administrative turnover of key person-
nel was disruptive; the cost of installing the infrastructure to support a degree
program were underestimated; and accreditation for the BFA degree had been
denied. On a positive note, Linda felt that her efforts to stabilize the school
had provided significant training about how to run a professional arts organi-
zation.[4] Mindful of this, there were additional problems created by the struc-
ture created to house the institute. Linda would not be involved again until
late in the decade.

Early on, the trustees determined to hire an internationally known architect
with the understanding that an important building was a felicitous way to make
a statement for the school. Postmodern architecture was then all the rage—
that is, a rejection of the canons of Modernism, functionalism, and emphasis
of structure.

Charles Moore of the firm of Moore Ruble Yudell, a leading exponent of
the movement, then chaired the department of Architecture and Urban Design
at the University of California at Los Angeles. (He was a recipient of the AIA
Gold Medal in 1990 and the inaugural holder of the O'Neil Ford Chair, School
of Architecture, University of Texas at Austin.) Upon considering their options,
the trustees chose Charles Moore who described his concept for the project
as "on the scale of a Mediterranean village that would be compatible with the
Spanish buildings of the McNay estate." What's not to like?

At the initial meeting with Moore in San Antonio, most of the trustees
were delighted to be involved in designing the new building using Styrofoam
volumes as their medium. As an architecture student, Margaret Pace Willson
had reservation about the participatory nature of the process. By 1985, Moore
was in residence in Austin; however, Renzo Zecchetto, an associate of his
California firm, attended the monthly meetings of the board along with Tom
Guido, the general contractor, and structural engineers, Feigenspan Pinnell.
No architecture firm based in Texas was involved. Dr. Robert Cardinale, presi-
dent of the art institute from 1985 to 1990, exercised significant influence.[5]
An extenuating circumstance for Moore's distance from the process may have
been his declining health, already evident to his students at UCLA.[6]

Alas, construction could not be completed due to cost overruns, which ballooned from $3.2 million to $5 million for the projected 40,000 square-foot campus. In the fall of 1988, classes were held in studios that had been completed in approximately 16,000 square-feet of the Moore building. Space was also utilized in the institute's adjacent Helen and Everett Jones Building, which had been dedicated in 1976. Chapter 11 bankruptcy was filed in 1992 and in August of the following year, the school closed for good. The Moore building—which had required $500,000 annually to operate—stood vacant for ten years and could not even be used for storage. It was demolished by the McNay Art Museum in 2003 to make way for the Jane and Arthur Stieren Center for Exhibitions which opened in 2008.

In *Dreaming Red*, Linda wrote: "One of the practical insights I gained from that experience was to be careful not to put too much money into a building at the expense of the program and endowment. The other realization I had was that I did not like asking people for money. . . . I remembered both those lessons when I decided to form Artpace."

Three months after her divorce was finalized in 1991, Linda made a precipitant marriage to art aficionado Dick Roberts, who divided his time between San Antonio and London. Her first experience living abroad was transformative.[7]

Together the couple delighted in getting to know young British artists who produced challenging and exciting work. Upon reflection, Linda determined that the paramount value of the defunct Art Institute had been the artist-in-residence program which brought artists of international stature to San Antonio to work with students in intense six-week sessions. Their presence not only stimulated the students' growth but breathed life into the local art scene. She had the will and the resources at her disposal to generate that same artistic energy once again. Why wait?

The research required to found Artpace began early in 1993 and by that June, the Pace-Roberts Foundation for Contemporary Art was established. Seeking advice and information, Linda and Dick hired Lawrence Miller, formerly director of Laguna Gloria Museum in Austin as a consultant. Together the threesome visited exemplary organizations from coast-to-coast which supported artists doing provocative and powerful work. All of these organizations, such as

the Dia Center for the Arts in New York City and the Capp Street Project in San Francisco, hosted artist-in-residence programs. Invaluable advice and introductions were provided by Nancy Negley, a major art patron in San Antonio and beyond.

Girded with insights gained from the demise of the San Antonio Art Institute and with enhanced confidence as an artist known for her monochromatic mixed media collages, Linda Pace launched Artpace in 1995.[8] Her marriage to Dick Roberts was dissolved—as was the Pace-Roberts Foundation, which re-emerged in 2003 as the Linda Pace Foundation. The generous resources at hand eliminated the need to dissipate time and energies in solicitation. Linda initially projected funding Artpace at a rate of $500,000 annually out of her own pocket. Over the next seven years, the budget would grow to more than twice that amount. In those years, Linda provided all the financial support for Artpace. In 2002, a board of visitors was named who became stakeholders in Artpace's future and would assist in fundraising and planning. This would evolve into a more formal board of trustees.

And what better choice of location than one block from San Antonio's famed River Walk, the Paseo del Rio, in the bicultural, predominantly Mexican-American downtown district? A 1920s-vintage building at 445 North Main Avenue, once a Hudson automobile dealership, was acquired and renovated by the eminent local firm of Lake/Flato Architects.[9] The building had a stripped-down industrial feel which would accommodate ambitious art projects. Ted Flato gave it distinction through color as did interior designer Courtney Walker.

Artpace was created as a safe haven for artists to pursue their dreams, unfettered by fears that their creations might be deemed too risky, too ambitious, too confrontational, or too shocking. In an environment designed to encourage individual experimentation, Artpace would serve as an international laboratory for the creation and advancement of contemporary art. The exact terms of the program continue to evolve. As it stands, three times a year Artpace invites a renowned guest curator to choose three artists to live and create art in San Antonio for two months. Each residency cycle includes one international, one national, and one Texas-based artist. Each artist receives an on-site apartment and studio space, an honorarium, production money, travel costs, and the support of the full-time staff for two months. All art

made during the residency belongs to the artist. While in residence, artists are encouraged to share their ideas and become involved with the San Antonio and Texas art communities. Exhibitions that reflect the organizations' international scope are showcased in the Hudson Show Room.

Christopher Goldsbury died on April 10, 1997, at age twenty-five. In the desolation Linda experienced in the days and years ahead, she searched for a way to commemorate the life of her beloved son. An art park that would serve the public at large seemed the answer. Chris Park would be a quiet place where people could come for reflection and for interaction with art.[10]

In 2001, Linda bought the Tobin Aerial Survey building at 114 Camp Street, off South Flores, located less than two miles south of Artpace's Hudson Showroom. The Tobin building borders on San Pedro Creek, once a considerable waterway but for decades little more than a concrete drainage ditch. Built in 1926, the 83,000-square-foot building sits on a 2.5 acre lot— the perfect venue for the community of artists of which she would be integral. It was to be "an artful campus for the community, artists and the world to experience contemporary art." Across the street was an empty lot destined to become Chris Park. The one-acre park was designed by Jon Aherns of King's Creek Landscape Architecture with consultant Rosa Finsley. There are areas of repose and sites of play in the xeriscape of plants suited to the South Texas climate. Teresita Fernández, Artpace artist in 1998, conceived several visual experiences which commemorate the potential of the quotidian.

In an interview in 2005, a decade after its formal opening in January of 1995, Linda Pace said that Artpace has been more successful than she ever dreamed. She died of cancer on July 2, 2007, and Chris Park was the site of her memorial service. Her daughter Margaret, "Mardie," died only three years later, on April 30, 2010, in her early forties.

Let us wish that Linda could have foretold, or better yet dreamed, the future. In celebration of the 300th anniversary of San Antonio's founding in 2018, San Pedro Creek, a waterway that sustained the civil settlement and growth of the city, began undergoing a $175 million redevelopment. The goal is to restore the creek's cultural ecology as well as its ecosystem, so that it might become a place of recreation and revitalization, a place of culture and art.

Internationally regarded architect David Adjaye has been commissioned to design a building on Camp Street at the creek to house the Linda Pace Foundation's growing collection of adventurous artworks from the recent past —800 works of art and growing, according to Kelly O'Connor, formerly Linda's studio assistant and now collections and exhibitions officer.

As early as 2000, Linda had a clear vision of what the museum would be; construction of her "Ruby City" began in 2018. When Adjaye visited San Antonio in 2007 and met with Linda, they sketched out ideas and envisioned a building that would resonate with her dream of the Ruby City—"a place where artists and the wider community can be inspired to realize their own dreams through a meaningful experience with contemporary art."[11]

Linda clearly stated her mission, and her legacy of art patronage has been perpetuated by Artpace and the Linda Pace Foundation. In 2015, on the twentieth anniversary of the founding of Artpace, it was noted that since 1995, the artist-in-residence program has supported 190 artists from over 59 countries and 6 continents. Many of these artists have gone on to win prestigious awards, including five MacArthur Fellow awards, five Turner Prize nominations and two wins, and two Venice Biennale Golden Lion awards. Artpace has also broadened the horizons of South Texans of all ages by exposure to the exploration of the possible. In 2015, Artpace received additional support from the City of San Antonio Department of Culture and Creative Development, the Andy Warhol Foundation for the Visual Arts, donors to the Linda Pace Memorial Fund and others.

Indeed, Artpace has been just as successful as Linda ever dreamed. Even so, she continues to be referred to in the press as the Pace Food Heiress— up from humble beginnings, when she sterilized her baby bottles alongside the picante sauce jars in her parents' home kitchen. And she won't soon be forgotten: near the entrance of San Antonio's "enchilada red" Central Library, the visitor can find "Days," a sculpture created by the artist Jesse Amado, the first Texas artist in the residence program. It is composed of 22,722 crystals, each representing a day in the life of Linda Pace. "Days" was commissioned by the Linda Pace Foundation to commemorate her birthday.

Pace Foods Ltd. won the "Picante Wars" hands down. By the early 1990s, Pace was the top-selling Mexican food sauce, available nationwide as well as in Canada, Mexico, Great Britain, and in military commissaries around the world. The sale of Mexican sauces from all purveyors now tops $640 million, outdistancing ketchup for the first time as the nation's number one condiment with a huge increase anticipated.

In 1994, Pace had revenues of $220 million and employed 470 associates in its Near East Side plant. Kit Goldsbury made that happen during his long tenure beginning in 1979 as President then as Chairman and Chief Executive Officer. Known as an accomplished marketer as well as for his devotion to teamwork and competition, he was also a man who maintained a low profile and declined interviews with the press.

He preferred that Rodney Sands—Pace President and Chief Operating Officer—be seen as the "point man pointing to the future." Prior to joining Pace, Sands worked for Uncle Ben's Foods in Houston and Anderson Clayton Foods in Dallas, the first of the specialists Goldsbury lured away from the giants. Sands's skill in negotiating and selling Pace Foods to the Campbell Soup Company for $1.1 billion was big news nationally.[1]

One headline said it all: "Lid Kept Tight on Pace Buyout." Serious talks with representatives of the so-called Top Ten international food companies had been underway for some time.[2] Goldsbury rejected the $750 million offer from Kraft General Foods because they refused to guarantee that employees would retain their jobs. Talks between Pace Foods and Campbell's intensified only in the final months of 1994. Investment bankers and merger and acquisition attorneys now took the lead as principal negotiators. The code name used was "Silver," and perfect secrecy was maintained. Robert Peche of the San Antonio Economic Development Foundation observed that word of the deal did not get out until the time was right.

Once Campbell made its offer—about twenty times Pace's operating earnings according to Bloomberg Financial Markets Commodities News—Goldsbury sat down to draft an employee bonus system. Based on average

monthly service and months served, employees would benefit from the sale after Federal Trade Commission approval. Everyone working for the company was generously rewarded for their service as were others including Pace family members Margaret, Linda, and Paul. The founder, David Pace, had died the previous year but his wife, Jean Pace, was also a beneficiary. With the Pace-Campbell marriage consummated, it was stated that there would be no immediate change for the San Antonio-based company other than the termination of Goldsbury's role as chairman. Rod Sands observed that "it was a huge change working for anyone other than Kit."[3]

But there were storm clouds on the horizon. The lead story in the *San Antonio Business Journal* of May 8, 1998, was headlined "Pace may be targeted for downsizing." The previous year, "Pace relinquished the top spot in the Mexican sauces and marinades category of the retail food market to Plano, Texas-based snack food giant Frito-Lay, a division of PepsiCo, Inc."[4] Why? Among the reasons cited, Frito-Lay benefited from an aggressive television advertising campaign promoting its products while Campbell's cut back on the Pace advertising budget.

The opportunity for plant consolidation and head-count reduction was deemed inevitable.

One month later, Pace's roots as an authentic Alamo City legend were severed with the press announcement that "Pace won't be made by the folks in San Antonio."[5] With the goal of improving the efficiency of its manufacturing operation, Campbell's 1,000-employee plant in Paris—in northeast Texas near the Oklahoma border—had room for additional production. Pace employees, some who had been with the company for two decades, received severance pay and a six month continuation of medical benefits.

Rod Sands had stayed with Campbell's for two and a half years. He tendered his resignation twice, which Campbell's did not accept. He had signed a three-year contract as part of the acquisition requirements and only determined to leave after Campbell's told him of their plan to move production to Paris. They wanted him to lead the transition from San Antonio, which he could not do. He stated, "I had been involved in the hiring of many of our associates who I knew very well and could not take part in shutting down the plant and putting them out of work."

His resignation was finally accepted after it was understood how intensely he felt about not participating in shutting down the plant.[6]

It is of interest that the Pace Foods website at *www.pacefoods.com* features a statement that Pace Picante Sauce is still made by the recipe Dave Pace developed more than sixty years ago: "He would be proud that his products today are still produced David Pace's way with a focus on fresh taste."[7] Best that he is not here to comment.

After appropriate distributions to Pace family members, proceeds of the sale of Pace Foods to the Campbell Soup Company were used by Kit Goldsbury to launch Silver Ventures, a business holding company which would help fund the Goldsbury Foundation. The foundation is dedicated to San Antonio area entities primarily benefiting childrens' causes and education.

In 2002, Silver Ventures purchased the defunct Pearl Brewery from the Pabst Brewing Company which had ceased beer production in 2001. (In 1985, Pearl's parent company purchased Pabst and assumed the Pabst name.) The twenty-two acre site is just north of downtown, two blocks west of Broadway and backing on to the then weed-chocked banks of the San Antonio River. The original brewery was founded in 1883 and landmark buildings dating from that period were slated for demolition. Goldbury's first step in planning a development scheme was to commission the firm of Ford, Powell & Carson to prepare a historical survey. Documentation of the original appearance of the brewery structures, most of which had been altered through the years, was their charge. The task was implemented by Chris Carson, principal, and historic preservationists Carolyn Peterson, principal, and Jeffrey Fetzer, senior associate of the firm. More recently, Fetzer has been involved as the Preservation Architect for Silver Ventures as an independent consultant and has earned the accolade of "protector of the historic fabric" at Pearl.

Next, charettes of "place-making consultants" helped define Goldsbury's intent to create something specific to San Antonio that focused on food. It was also determined to allow development to materialize gradually through a mixture of renovation and new construction. Architectural reporter Vincent Canazaro observed that "in making Pearl both unique and local, it is a blend of education, entertainment, retail, culinary and fitness concerns as well as live-work residents . . . a pedestrian friendly village."[1]

Equally innovative was the timely transformation of the long-neglected section of the San Antonio River between midtown and the Pearl. Silver Ventures was again part of the team effort, in liaison with the San Antonio

River Authority and others. The so-called Museum Reach-Urban Segment, from Lexington Avenue to Josephine Street, was inaugurated on May 30, 2009, by two-term mayor Phil Hardberger, 2005-2009, an enthusiastic supporter of the enterprise. At the turnaround basin, barges deliver passengers to the Pearl, a kind of "second front door." Other amenities include hike-and-bike trails, landscaping and boat landings, as well as public art funded by private donations raised by the San Antonio River Foundation. Ford Powell & Carson was the lead design firm with Boone Powell, principal-in-charge, in association with Zachry Construction.

The river-as-avenue links the Pearl to another converted brewery. Founded in 1895 and built in the style of "Mad" King Ludwig of Bavaria, it was the former home of the Lone Star Brewery. During Prohibition, the building was abandoned and never again occupied by its original owner. The Lone Star name was taken over by a new company that opened a plant in south San Antonio. In the 1970s, this grand old building was transformed into the home of the San Antonio Museum of Art. The opening of the Gloria Galt River Landing serving museumgoers was also celebrated in 2009.

The next priority was the Pearl Brewery Redevelopment Plan crafted by Lake/Flato Architects, which has proved to be an ever-evolving document—and the recipient of the American Institute of Architects Honor Award for Regional and Urban Planning in 2014.[2] The overall complex would be developed to express the flavor of the industrial legacy of the site and reflect the identity of the historic brewery. Much of the original building stock was salvaged and repurposed. To extend the industrial vocabulary, brewery equipment was taken out and put to new use, often in a playful way. Injecting history into new spaces is encouraged by the Pearl staff, who have opened up warehouse space and who work with designers and artists. Jeffrey Fetzer observed that "we are taking parts and pieces and giving them new life rather than making museum-like displays while making sure we are maintaining the character of the building and artifacts."[3] The use of levelers from the brew tanks as site bollards is just one example of the incorporation of recycled elements in the design of the site that recalls the history of the brewery. Reclaimed brew tanks serve as cisterns to harvest half of the roof drainage for on-site irrigation.

This is not the first time a San Antonio development has made re-imagining old artifacts a priority. In the 1990s developers of the Quarry Market built a shopping center around the smokestacks from the century-old Alamo Cement plant.

Perhaps the most telling instance of Kit Goldsbury's patience and determination concerns his four-year quest to convince the Culinary Institute of America that San Antonio was the perfect spot for the Center for Foods of the Americas.[4] He is credited with making the largest single donation ever made to culinary education. The bulk of his gift of $35 million provides scholarships for students, especially Latino culinary workers, to attend the center's thirty-week program. The best of those students are then given full scholarships to attend the Culinary Institute's campus in Hyde Park, New York, for one- or two-year degree programs specializing in foods from Latin America. Goldsbury's gift will also fund a $7 million expansion of the Center for Foods of the Americas in San Antonio; $5 million will go to build a comparable program for Latin American food studies at the Hyde Park campus. For the culinary school to

Pearl Brewery Stable, 1894. Z-1817. UTSA Library Special Collections.

start with such promise the prestigious Culinary Institute of America was required to branch out in a way it had never previously done.

Another instance of an educational component was the Aveda Institute, the the first tenant in the Pearl development. Cosmetology-related courses were offered in 25,000 square feet of space in the brewery's former garage on Grayson Street. In June of 2013, the institute relocated to a smaller space on the far north side of San Antonio.

The Pearl Stable is a prime example of several such exemplary projects. Chris Carson was principal-in-charge of the Ford, Powell & Carson team with Jeffrey Fetzer, project architect and Ellen Berky, specification writer. Designed by local architect Otto Kramer and constructed in 1884 to house the horses that pulled the beer wagons of the Pearl Brewery, the stable embodies the elegance which long-ago generations imbued their most utilitarian structures.[5]

In the original two-story building which is elliptical in plan, horse stalls were arranged around the perimeter of the ground floor. The second floor served as the hay loft from which feed could be dropped through chutes to the stalls below. A cupola provided ventilation. The structure remained a functioning stable for almost three decades before motorized vehicles replaced the horse-drawn wagons.

The building was then converted into a storage facility. In the 1950s, it was re-purposed as a popular hospitality room named the Pearl Corral, with a wild west theme. In 1971 it was re-purposed yet again, with a "Gay Nineties" theme, and featuring an exact reproduction of Judge Roy Bean's famous Jersey Lily bar.

Over the years, unsympathetic modifications were made to the building, including the removal of the brick and stone pediment over the entry as well as the replacement of wooden windows with ones of aluminum or brick in-fills.

Also at mid-century, cream-colored paint was applied to most of the brewery buildings, causing moisture to be trapped which further damaged the masonry. Jeffrey Fetzer recalled the story about a local paint company that came up with a color called "Pearl Beige," a clever marketing ploy.[5] To determine which chemicals were needed to safely dissolve the paint, forensic work and research were required. The brick used to build the brewery came from Calaveras near Elmendorf, a famed brickyard no longer in operation.

The task of restoring the historic stable required minor exterior modifications to accommodate the building's new uses as a banquet and events venue. As part of the renovation, the false-front pediment was reconstructed and a cupola was installed based on plans drawn on silk from the brewery archives. New windows similar to the original windows filled extant openings. The interior was reconfigured to create an elliptical assembly space between two outer elliptical spaces dedicated to pre-function activities. The challenges which confronted the design team were best described at the time by Doug Lipscomb in *Texas Architect*:

> Accommodating the service entry posed a significant problem. The building's elliptical geometry combined with its central location within the complex does not provide for a "back of the house" where services can be neatly hidden from view. Fetzer and the design team also faced problems related to the incorporation of [mechanical, electrical, and plumbing] systems. Because the owner wanted the original roof structure exposed and visible from the interior spaces, there was no place to conceal lighting and other systems. The solution employed was to construct a second roof below the parapet but above the original structure . . . which created an interstitial space in which the systems were concealed. To express the brewery's legacy inside the building, old beer bottles found on the site were incorporated into the design of the chandelier and other light fixtures. A few horse stalls were recreated inside the main assembly space opposite the stage.[6]

Meticulously returned to its former glory, Pearl Stable's beautiful historic structure now offers twenty-first-century patrons the opportunity to inhabit a space that, while common enough to accommodate draft horses in the nineteenth century, is uniquely elegant today.[7]

In terms of "place-making" specific to San Antonio, the visionary redevelopment of the Pearl is a blend of selective renovation and new construction rendered in a durable industrial aesthetic. The Full Goods Warehouse, the first mixed-use building redeveloped at the Pearl, became the incubator for subsequent phases of the project. Lake/Flato Architects and Durand-Hollis

Rupe, in collaboration with DHR Architects and Rio Perla Development, remodeled the 67,000-square-foot warehouse. The 1874 building in its industrial past served as the brewery's warehouse (the term "full goods" referred to filled bottles). The one-story building, reduced to half its original size, was stripped to its steel frame, much of which is still visible, and expanded to two floors connected by a series of catwalks. The L-shaped building is cut through with two-story breezeways along both legs to create something akin to a shaded public street. The east side, highlighted by a perforated screen, joins Full Goods to a building housing Live/Work units. The design maximizes density and provides residential and commercial spaces to house local businesses and restaurants.

Pearl Brewery Brewhouse, 1894. Z-1822-A-3. UTSA Library Special Collections.

While the Pearl development as a whole describes a process designed to foster social sustainability through building of community, efforts at ecological sustainability are also in evidence.[8] Seven hundred solar panels provide 200 kilowatts of energy to the Full Goods Warehouse, about twenty-five percent of the building's total energy use. There is also an educational component: an interactive display for visitors to see how solar panels work and how much energy is being created. The intent is for this is to be a learning laboratory for CPS Energy and for other developers as well. Silver Ventures funded $950,000 of the $1.35 million in solar equipment. CPS Energy put in the remaining $400,000. This is another way for CPS Energy to push ahead with efforts to diversify their portfolio of renewable energy resources.

In another instance of sound ecological practices, Rialto Studio Landscape Architects planned the entire site to control and cleanse stormwater runoff from Broadway as it flows toward the San Antonio River. Wetlands with a waterfall are planted with lush aquatic landscaping along the pedestrian descent to the River Walk.

The ornate, Second Empire-style Brewhouse, designed by Chicago architect August Maritzen, noted for his numerous designs for breweries across the country, was also built in 1894. It has been restored and incorporated into the Hotel Emma, a 146-room boutique hotel. The Brewhouse now contains a restaurant and microbrewery, Southerleigh, in the original brewing rooms. Other elements in the historic portions of the hotel are:[9]

Sternewirth, a large bar named after the employee bar from the Brewery's heyday, features a 24-foot-long ornate wooden bar with a top made from a pecan tree trunk unearthed during excavations on the property.

Larder, a delicatessen associated with the hotel restaurant, Supper, offers specialty and prepared foods.

Elephant Cellar Ball Room, named for the enormous beer storage tanks housed in the room and now decorating the side walls of the room.

Brewmeister's Office, built in 1938 along with additional Cellars, is being restored to highlight its decorative cement tile walls and floor, mahogany wood trim and vaulted plaster ceiling. It will be used as an intimate private dining or event space adjacent to the Ball Room.[10]

The Library, assembled by and mostly acquired from Sherry Kafka Wagner, author, playwright, urban planner and historian, this 3,700-volume collection incorporates many early technical works related to brewing and chemistry. Today it is a semipublic space used for book club meetings and author presentations.

The following are comments by the selection jury which named the Pearl Brewery Redevelopment Master Plan by Lake/Flato the recipient of the 2014 American Institute of Architects Honor Award for Regional and Urban Design. (Additional credits listed in Note One, Chapter Ten.)

The Pearl Brewery achieves its stated goals of creating a sustainable destination while maintaining the identity of the historic brewery; it is a well-done, pedestrian-focused development that reflects the unique character and culture of San Antonio.

This project has served as a catalyst for green urban vitalization in a long-neglected portion of San Antonio's inner city.

The Pearl will be a gathering place for San Antonians centered around extraordinary culinary and cultural experiences. A place where food, education, commerce, art, ideas and urban living come together. A dynamic and evolving environment committed to stewardship and learning.

The development has attracted new residents, small businesses, retail, and non-profits—a visionary mixed-use urban village where honesty and modesty prevail spiced with playfulness, never replicating the national chain-store experience. It is the new focal point of the city's River Walk. As such, it is a favorite destination for events such as a weekly farmer's market, holiday festivals like the annual Tamales! at Christmas, and the Blessing of the Pets in honor of Saint Francis.

Rod Sands who served with Pace Foods for fifteen years and later with Silver Ventures offered his perspective on the Pearl: "Kit Goldsbury was the only person with the vision to see what Pearl could become and he took the large financial risk to develop the Pearl. He took the risk and has made large improvements as part of his desire to give back to the city of San Antonio."[11]

That great things may come from small beginnings is captured in the ancient proverb, "mighty oaks from little acorns grow." It all began seventy years ago when Dave and Margaret Pace made batches of picante sauce in their home kitchen, using only the freshest ingredients, with Dave's friends at the golf shop functioning as guinea pigs. Dave never had the chance to see his empire reach its full height; but then again, the best may still be yet to come.

AFTERWORD

Since 1996, the Goldsbury Foundation has been quietly providing chari-
table support for nonprofit organizations serving children and their
families in San Antonio. In 2013, the foundation announced a $20 million
grant to the Children's Hospital of San Antonio (formerly known as the Santa
Rosa Children's Hospital) to support the transformation of the downtown
campus. A portion of that grant was also set aside to fund the creation and
implementation of an innovative Culinary Medicine initiative, designed to
encourage healthy eating among our city's children. The program, known as
CHEF (Culinary Health Education for Families) represents a unique approach
to tackling the high rate of childhood obesity and diabetes in San Antonio
and South Texas.

Thanks to the Goldsbury grant, the hospital will be the first in the coun-
try to have a Culinary Institue of America-designed Teaching Kitchen located
in the heart of the institution. There, children and their families, physicians,
associates, and the general public will have the opportunity to work with the
dedicated CHEF team to increase their nutritional knowledge and understanding
as well as their practical culinary skills. The grant also supported the creation
of a 2.3-acre garden surrounding the urban-based hospital—providing a
welcome oasis for play and prayer for the ill and injured children in the care
of the hospital. The garden was designed by Overland Partners, Architects,
Rick Archer, principal-in-charge, and landscape architect Catherine O'Connor,
CO'DESIGN.

In the early summer of 2015, the Goldsbury Folundation expanded the CHEF
network to include the San Antonio Botanical Garden, the YMCA, and the Boys
and Girls Clubs. Funding from the foundation supported the construction of
three more CIA-influenced Teaching Kitchens at geographically dispersed
locations. CHEF programming at those locations will impact the lives of tens
of thousands of children each year.

Suzanne Mead Feldmann *Chief Executive Officer,*
Goldsbury Foundation

Chapter One

[1] Michael C. Hennech and Tracé Etienne-Gray, "Brewing Industry," *New Handbook of Texas Online*, Texas State Historical Association, *https://tshaonline.org/handbook/online/articles/dib01*; Michael C. Hennech, rev. by Laurie E. Jasinski, "Pearl Brewing Company," *New Handbook of Texas Online*, Texas State Historical Association, *https://tshaonline.org/handbook/online /articles/dipgx*.

[2] Otto Koehler House Texas Historical Marker, long description. *History of the Koehler Cultural Center* was written by Mary Hollers George who also wrote and produced a television documentary, "The Future of the Past: The Koehler Cultural Center," for the Alamo Community College District.

[3] Margaret Pace Willson, *Margaret Pace Willson: A Many Faceted Life* as told to Patsy Sasek (San Antonio: self-published, 2006) pp. 1-17. Admiration for Otto von Bismarch, first chancellor of modern Germany, inspired the popularity of the name, Otto.

[4] Ibid.

[5] Joe Holley, "Pearl Brewery Story is Saga of Three Emmas," *Houston Chronicle*, November 28, 2014, pp. 1-5.

[6] The Holley article gives an inaccurate account of the trial, at odds with the more complete press account.

[7] The *San Antonio Light* published daily front page accounts of the trial from January 13 to January 23, 1918. Clipping files, Special Collections, UTSA Institute of Texan Cultures. Also accounts may be found in the Newark and Salt Lake City papers from 1914.

[8] Turley's son, Vernon, lived with the newlyweds until his own marriage. In the 1920s, Vernon is listed in city directories first as a deputy sheriff then as "chauffeur for Johanna, Mrs. Edward Steves," an indication that he was not tainted by association. The Turleys subsequently moved to a farm on the Scenic Loop Road twenty miles north of town to pursue the raising of livestock.

[9] Marilyn McAdams Sibley, *George W. Brackenridge* (Austin: University of Texas Press, 1973). p. 161: "While Brackenridge maintained a fine wine cellar, he believed that ordinary individuals were not strong enough to handle hard liquor and that they needed to be protected from their own weakness. If the restriction was not honored, the property would revert to the University of Texas." See also David P. Green, *Place Names of San Antonio* (San Antonio: Maverick Publishing Company, 2002), pp. 34-35.

[10] "Pearl Brewing Company," *New Handbook of Texas Online*.

[11] Ibid.

[12] Almost three decades had passed since the death of the first Otto with its attendant tragedy and scandal, but from 1941 onward, evidence of the Koehler curse manifested itself in the lives of other family members. "Aged Man Killed on Road" (*San Antonio Express*, February 22, 1941, p. 1): "Adolf Engel, 74, was killed Thursday afternoon when struck by an automobile as he crossed the Austin Highway about one mile north of Selma. Engel was stuck at about 1:30 p.m. by a car driven by Mrs. Otto Koehler, 247 East Summit Avenue, who was going north."

No further mention was carried in the press. Then a year later: "S.A. Girl Killed in Auto Crash" (*San Antonio Light*, January 3, 1942, p. 1): "Marian Louise Hill, 17, Jefferson High School [senior], ROTC sponsor and Lasso girl, the daughter of Mr. and Mrs. Russell Hill [president of Maverick-Clarke Lithography Company] was instantly killed early Saturday morning when the auto in which she was riding leaped a curb and crashed

into the plaza in downtown New Braunfels. Held in the Comal County jail as driver of the car was Otto Koehler, Jr., 18, a military school student. . . . Koehler was uninjured. Miss Hill died of a fractured skull."

The following day, the *San Antonio Light*, January 4, 1942, p. 13, reported "Crash Death Charges Filed": "Complaints charging murder without malice and driving an automobile while intoxicated were filed in New Braunfels Saturday against Otto Koehler, Jr., Koehler was released under $2,000 bond in the first case and $500 in the other."

There was no further mention of court action; however, the *San Antonio Express-News* of August 6, 1943 (p. 8A) noted that Otto Jr. had entered the Air Force and would take preparatory preflight training. It may be assumed that service in World War II would was mandated in lieu of incarceration.

Otto Koehler, Jr., would spend more than a decade institutionalized in Colorado, having been committed there by his family because of drinking problems and mental instability. He was eventually released from the facility and died in Denver in May 1975. While the deaths involving Marcia Koehler and her son, Otto Jr., were tragic accidents, the nadir of the Koehler legend runs four generations deep in the family, whose name is still synonymous with Pearl Beer. The final episode in the story was provided by Mick Tolson in the *San Antonio Light*, January 19, 1992: "Koehler Curse: Generations of Beer Baron's Family Plagued by Tragedy and Scandal." Otto Koehler, III, 43, was charged with the macabre murder of a woman said to be his mistress. The gruesome details were front page news. Like his father, he was afflicted with both substance abuse and mental illness. He had also been declared incompetent in 1989 to handle the trust his grandfather had established for him. He was released on $500,000 bond but landed back in jail two months later. "Brewery Heir Lands Back in Jail After Threats on Sister [Marcia Koehler Hanson] Reported" (John Moulder, *San Antonio Express-News*, March 13, 1992, pp. B1, B3).

The state sought a murder conviction before the charge was reduced to voluntary manslaughter under a plea bargain. (Nicole Fox, "Brewery Heir Gets 20 Years in Slaying," *San Antonio Express-News*, October 24, 1995.) Koehler was released on parole from Huntsville (Texas) Penitentiary on August 15, 2012. Less than two months later on October 11, 2012, he was released from parole, his rehabilitation having been accomplished.

Chapter Two

[1] Margaret Pace Willson, *Margaret Pace Willson: A Many Faceted Life* as told to Patsy Sasek (San Antonio: self-published, 2006), pp. 1-116.
[2] "Pioneers in Peppers". *San Antonio Express Magazine*, 1949, pp. 14-17. Courtesy of John Jockusch.

Chapter Three

[1] Claudia Hueser. "Pace Foods, Inc.: A Texas Success Story" (Chicago: Pace Foods Inc., press release, 1995).
[2] The author did a series of paintings of sprouting fence posts in the state of Chiapas, Mexico, in 1981.

Chapter Four

[1] Linda Pace et.al. *Dreaming Red: Creating ArtPace* (San Antonio: Linda Pace Foundation, 2003), pp. 39-40.
[2] Willson/Sasek, p. 92.

Chapter Five

[1] Pace, p. 38; Willson / Sasek , pp. 92-93.
[2] The details of the breakup of the Pace marriage and its impact on the business are documented in Margaret Pace Willson's autobiography, pp. 103-113.
[3] Interview by Mary Carolyn Hollers George (hereafter MCHG) with Eugene Ames, Jr., April 18, 2015.
[4] The years of Margaret's marriage to Robert Willson are covered in her autobiography beginning with Chapter 13, "New Works," p. 117. MCHG interview with Jean Pace, May 19, 2015.

Chapter Six

[1] San Antonio Express-News, September 7, 1986, p. K1.
[2] Laura Lambeth, "Expansion gives Pace Foods growing room," San Antonio Light, August 4, 1983, p. B3. "Picante plans new East side plant," San Antonio Light, April 20, 1982, p. 2.
[3] Interview by MCHG with Chris Carson, March 6, 2015. Mary Carolyn Hollers George, O'Neil Ford: Architect, (College Station: Texas A & M University Press, 1992), pp. 132-33.
[4] The building now houses Lucifer Lighting, owned by Suzanne and Gilbert Matthews. The address is cited as 3750 North PanAm Expressway.

Chapter Seven

[1] T.D. Honeycutt, "Pace Marketing Picante Sauce in Monterrey," San Antonio Light, October 1, 1991, p. E1.
[2] David Bennett, "Lid Kept Tight on Pace Buyout," San Antonio Expresss-News, November 11, 1994, p. A10.
[3] Mick Vann, "Who's a Pepper?" Austin Chronicle, August 22, 2008, pp. 1-4.
[4] Melanie Young, "Home-grown and Growing," San Antonio Express-News, February 20, 1994.

Chapter Eight

[1] Pace, Dreaming Red, pp.42-45.
[2] Beginning in the early 1970s, the author was on the institute's then twelve-member board of trustees, chaired by Maj. General Alden H. Waitt, Ret. A new 11,000-square-foot building, the gift of Helen and Everett Jones, was completed in January of 1976 to house the school. Designed by architects E.B. Flowers and Isaac Maxwell, the structure today serves as the administrative offices of the McNay Museum.
[3] Margaret Pace (Willson) was also one of six founders of Southwest School of Art and Craft, later the Southwest School of Art. Through her generosity, the Picante Paper Studio was funded in 1984. Maria Watson Pfeiffer, School by the River (San Antonio: Maverick Publishing company, 2001) pp. 183-186.
[4] Dan Goddard, "San Antonio Art Institute," analysis commissioned by the Southwest School of Art, 2010, and made available to the author. Documents of the Art Institute are housed in the archives of the McNay Art Museum Library, Ann Jones, Head Librarian.
[5] Tom Guido, personal communication, May 30, 2015. The firm of Renzo Zecchetto Architects, Inc. is now based in Los Angeles.
[6] Maggie Valentine, Ph.D, personal communication, June 4, 2015.
[7] Pace, Dreaming Red, pp.47-50.
[8] Dan R. Goddard, "Artpace Founder Invited the World to San Antonio," San Antonio Express-News, July 3, 2007, p. A10. Pace, Dreaming Red, pp. 46-50.

[9] Concerning the evolution of Artpace, an orientation session with Chris Castillo, administrative assistant to the Artpace director's office on June 3, 2015, was invaluable. Documentation provided has been integrated into the text of Chapter Nine.

[10] Pace, *Dreaming Red*, pp. 109-111.

[11] Steve Bennett, "Ruby City Museum to become Art Jewel for the South Side, "*San Antonio Express-News*, September 17, 2015, pp. A1, A9.

Chapter Nine

[1] Lesli Hicks, "Pace-Campbell Deal Sealed," *San Antonio Express-News*, ,January 31, 1995, pp. A7, A10.

[2] David Bennett "Lid kept tight on Pace buyout," *San Antonio Express-News*, November 29, 1994, pp. A10, A11.

[3] Lesli Hicks, "Salsa king's deal reaps new riches: Billion Dollar sale cast spotlight on entrepreneur," *San Antonio Express-News*, December 1, 1994, A1, A16.

[4] Personal communication, Rod Sands to MCHG, June 24, 2015.

[5] Sebastian Weiss, "Pace may be targeted for downsizing, analysts say." *San Antonio Business Journal*, May 8, 1998, p.1. The Frito Company, a corn chip business, was founded by Charles Elmer Doolin in San Antonio in 1932. The company's headquarters were moved to Dallas the following year. Also in 1932, the Berry family opened La Fonda on Main Avenue on the northern edge of San Antonio —then and now the preeminent destination for fine Mexican cuisine, a tradition continued today by Cappy and Suzy Lawton.

[6] Sanford Nowlin, "Pace won't be made by the folks in San Antonio," *San Antonio Express-News*, June 3, 1998, A1, A6.

[7] Letter, Rod Sands to MCHG, July 8, 2015.

[8] Today, the Campbell's organization has a Pace Brand manager as well as a Pace public relations specialist. No response to letters of inquiry from MCHG, dated February 12 and May 25, 2015 have been received.

Chapter Ten

[1] Vincent Canazaro, *Texas Architect*, November-December 2009, pp. 46-51.

[2] Additional credits cited in the Honor Award along with Lake/ Flato include: Owner, Silver Ventures; Associate architects, Durand-Hollis Rupe; RVK Architects; Ford Powell and Carson; WGW Architects. Engineers (Civil): Pape-Dawson Engineers; Engineers (Mechanical): Beyer Mechanical; Engineers (Structural): Danysh & Associates. General contractors: Artistic Builders, Joeris Construction, Metropolitan Contracting, Harvey Clear Builders; Landscape Architects, Rialto Studio; Lighting, Brown Design Consultants; Lang Lighting. Source: American Institute of Architects press release.

[3] Steve Bennett, "Pearl History Will Live On," *San Antonio Express-News*, January 26, 2014, p. A1.

[4] Mick Vann, "Who's A Pepper?" *Austin Chronicle*, August 22, 2008, p. 4.

[5] Doug Lipscomb, "Recast Pearl," *Texas Architect*, May-June, 2007, pp. 36-41.

[6] Jennifer Hiller, "Rebuilding Pearl," *San Antonio Express-News*, September 26, 2008, p. C1. The load bearing limestone building was dismantled and reassembled by Curtis Hunt, Jr. of Hunt Restoration, a third generation San Antonio mason, who also restored all of the historic masonry buildings, as well as build some of the new masonry construction at Pearl.

[7] Doug Lipscomb, "Recast Pearl," *Texas Architect*, May-June, 2007, page 41.

[8] Two years later, a few miles toward downtown from the Pearl Brewery, between Broadway and Alamo on Fourth Street, adjacent to the residence of Daniel and Annie Sullivan, a stable and coach house designed by architect Alfred Giles was built in 1896.

It was considered to be one of his master works. In 1971, when the Giles building was sold to the Light Publishing Company after many changes of ownership, it became apparent that the landmark would be destroyed if it was not moved soon. When it was doomed for destruction, saving it challenged the resolve, resources and ingenuity of an army of devotees. The building was ultimately dismantled and reassembled as the grand entrance of the Botanical Gardens at 555 Funston. The saga is documented in the *Architectural Legacy of Alfred Giles* by MCHG (Trinity University Press in 2006, pp. 62-67).

[9] Creighton A. Welch, "Soon to Be Solar," *San Antonio Express-News*, July 4, 2008, pp. 1 C-6 C.

[10] Letter, Jeffrey Fetzer to MCHG, August 24, 2915.

[11] Steve Bennett, "Pearl's New Hotel Emma Pays Allegiance to Brewery's Past," *San Antonio Express-News*, September 14, 2015, pp. A 1-A7.

[12] Letter, Rod Sands to MCHG, June 24, 2015.

SOURCES CONSULTED

Books

Pace, Linda; Russell, Jan Jarboe; Heartney, Eleanor; and Kanjo, Kathryn. *Dreaming Red: Creating ArtPace*, San Antonio: Linda Pace Foundation, 2003.
Willson, Margaret Pace as told to Sasek, Patsy, *Margaret Pace Willson: A Many Faceted Life*, San Antonio: self-published, 2006.

Articles

The Texas Archives collections of the San Antonio Central Library are the source for the majority of newspaper articles listed below. The American Institute of Architects, San Antonio Chapter, assisted in locating needed magazine references. Tom Shelton. Special Collections, University of Texas at San Antonio, Institute of Texan Cultures, was a valued source as always.
Baugh, Josh. "Festival Offers True Taste of San Antonio," *San Antonio Express-News*, December 2, 2012, B3.
Bennett, David. "Famous Salsa Launched from a Tiny Back Room," *San Antonio Express-News*, January 31, 1995, pp. A10-A11.
— — —. "Lid Kept Tight on Pace Buyout," *San Antonio Express-News*, November 29, 1994, pp. A10-A11.
Bennett, Steve. "Pearl's History Will Live On," *San Antonio Express-News*, January 26, 2014, pp. A1, A-23.
— — —. "Pearl's New Hotel Emma Pays Allegiance to Brewery's Past," *San Antonio Express-News*, September 14, 2015, pp. A1, A7.
Canizaro, Vincent. "Place-Making in Progress," *Texas Architect*, November-December, 2009, pp. 46-51.
Goddard, Dan R. "ArtPace Founder Invited the World to San Antonio," *San Antonio Express-News*, July 3, 2007, 10A
Greenberg, Mike. "Pearl Keeps Its Promise," *San Antonio Express-News*, May 28, 2006, pp. J1, J7.
Grondahl, Paul. "The Heat Goes On," Albany, *New York Times Union*, August 16, 1995, D1.
Hicks, Lesli. "Lid Kept Tight On Pace Buyout," *San Antonio Express-News*, November 29, 1994, pp. A1, A16.
— — —. "Salsa King's Deal Reaps New Riches," *San Antonio Express-News*, December 2, 1994, pp. A1, A16.
— — —. "Pace-Campbell Deal Sealed," *San Antonio Express-News*, January 31, 1995, pp. A7, A10.
Hiller, Jennifer. "Rebuilding Pearl," *San Antonio Express-News*, September 26, 2008, p. C1.
Holley, Joe. "Pearl Brewery Story is Saga of 3 Emmas," *Houston Chronicle*, November 28, 2014, pp. 1-5.
Honeycutt, T.D. "Pace Marketing Picante Sauce in Monterrey," *San Antonio Light*, October 1, 1991, p. E1.
Lambeth, Laura. "Picante Plans New East Side Plant," *San Antonio Light*, April 20, 1982, p. 2.
— — —. "Expansion Gives Pace Foods Growing Room," *San Antonio Light*, August 4, 1983, p. B3.
Lipscomb, Doug. "Recast Pearl," *Texas Architect*, May-June 2007, pp. 36-41.
Nowlin, Stanford. "Pace Won't Be made by the Folks in San Antonio," *San Antonio Express-News*, June 3, 1998, pp. A1, A6.
Parker, J. Michael. "Pace Eulogized As An Artist's Best Friend," *San Antonio Express-News*, July 3, 2007, p. A10.

Pesquera. Adolfo. "Precious Restoration," *San Antonio Express-News*, May 25, 2006, pp. C1, C6.

Phelon, Craig. "They Call Him 'Dr. Pepper'," *San Antonio Express-News*, August 26, 1990, pp. 11-12.

Poling, Travis E. "Pearl Brewery Sale a Done Deal," *San Antonio Express-News*, August 22, 2002, p. A10.

Spicer, Emily. "School for Stylists to Open in Former Brewery," *San Antonio Express-News*, November 16, 2004, p. B3.

Tedesco, John. "Farmers' Market Bears Fruit at Pearl," *San Antonio Express-News*, April 12, 2009, p. B4.

Vann, Mick. "Who's a Pepper?" *Austin Chronicle*, August 22, 2008, pp. 1-4.

Verhovek, Sam Howe. "Making Jalapeños for Tender Tongues," *New York Times*, May 15, 1996, pp. C1, C7.

Weiss, Sebastian. "Pace May Be Targeted for Downsizing, Analysts Say," *San Antonio Business Journal*, May 8, 1998, p. 1.

Welch, Creighton A. "Brew House Unveiled," *San Antonio Express-News*, January 18, 2008, p. C1.

— — —. "Soon-to-be-Solar," *San Antonio Express-News*, July 4, 2008, pp. C1, C6.

Wellinghoff, Jasmina. "We Are What We Eat," *San Antonio Woman*, September-October 2015, pp. 16-21.

Young, Melanie. "Home-Grown and Growing," *San Antonio Express-News*, February 20, 1994, n.p.

Press Releases and Analyses

American Institute of Architects Honor Award for Regional and Urban Planning for the Pearl Brewery Master Plan in 2014.

Goddard, Dan R. "San Antono Art Institute," analysis commissioned by the Southwest School of Art, 2010, and made available to MCHG.

Hueser, Claudia. "Pace Foods Inc: A Texas Success Story," Chicago: Pace Foods, 1995.

Interviews and Correspondence conducted by MCHG in 2015

Ames, Eugene. April 18

Carpenter, Lon. May 16

Carson, Chris. March 6

Castillo, Chris. June 4

Duncan, Baker. February 16

Feldmann, Suzanne Mead. November 3

Fetzer, Jeffrey. August 24, 25

Guido, Tom. Letter May 30

Pace, Jean. May 19

Pritchett, Mark. April 1

Russell, Jan Jarboe. June 17

Sand, Rodney. Letters June 24, July 8

INDEX

M

MacArthur Fellow Award, 55
Marcia and Otto Koehler Foundation for
 Arts, Culture and Education, 6
Marriner, Marcia E., 6–7
Maritzen, August, 55
Mays, Jack, 25,
McAskill, District Attorney, 4
McDonough, Pat, 28–29
McGimsey, Brooks, 4, 6
McGimsey B. B., 4
McNay, Marion Koogler, 40
McNay Art Museum, 42, 62
Mexican Food sauce, 46
Menlo College, 23
Menlo Park, California, 23
Mexican cuisine, 1, 12, 63
Mexican folk art, 32, 35
Military Base Commissaries, 25, 46,
Miller, Lawrence, 42
Miller Brewing Company, 36
Monroe, Louisiana, 9
Montera, 36
Monterrey, Mexico, 1, 39, 62, 65
Moore, Charles, 41
Moore Building, 42
Moore Ruble Yudell, 41
Morgan Stanley, 16

N

Near beer, 6
Negley, Nancy, 43
Nelson, George, 21
New Braunfels, Texas, 7, 61
New Mexico, 15, 20
New Orleans, Louisiana, 5
New York City, 4, 43, 51
North Texas, 47

O

Oaxaca, 38
Old El Paso Brand, 36,
Oppenheimer, Frederick, 22
Order of the Alamo, 23
Otto, Charlie, 1, 6
Otto Koehler Park, 5
Overland, Jean, 27
O'Connor, Kelly, 45
O'Neil Ford Chair, School of Architecture,
 University of Texas at Austin, 41

P

Pabst Brewing Company, 49
Pace, David Earl, 9–10, 12, 15, 34, 36, 39,
 47–48
Pace, Jean, 47, 62, 66
Pace, Linda Marie, 13
Pace, Margaret Gretchen Emma Bosshardt,
 2, 9–19, 21, 22–24, 26–28, 30, 40–41, 47,
 58, 60–62, 65
Pace, Paul David, 16, 23, 24
Pace 25 Club, 28
Pace-Campbell, 47, 63, 65
Pace Chair Company, 26
Pace Foods, 18, 21, 24–26, 28, 30, 36, 40,
 45–46, 48–49, 57, 61–62, 65–66
Pace-Koehler Pickles Company, 16–17
Pace Picante, Inc., 13, 29, 35, 36
Pace Picante Cookbook, 25
Pace Picante Jar, 13
Pace Picante Logo, 13
Pace Picante Sauce, 12–13, 15–20, 25, 29, 48
Pace Plant (Salado Creek), 30, 34–35
Pace Plant (North San Jacinto Street), 16,
 21, 22, 30
Pace-Roberts Foundation for Contemporary
 Art, 42–43
Pace's Pantry Prize, 14, 18
Papantla, Veracruz, Mexico, 38
Paris, Texas, 47
Paseodel Rio, 43
Patent Drawing for Dave's Ergonomic Chair,
 21–22
Pearl Beer, 1, 4, 6–7, 61
Pearl Beige, 52
Pearl Brewery Redevelopment Plan, 50, 57
Pearl Brewing Company, 1, 2, 6, 12, 14, 22,
 24, 49, 50, 52, 57, 63, 65–66
Pearl Corral, 52
Peche, Robert, 46
Pepsi-Cola/Frito-Lay, 36, 47, 63
Peterson, Carolyn, 49
Pet Incorporated, 36
Picante Wars, 36, 38, 46
Powell, Boone, 50
Pritchett, Mark, 22, 66
Progressive Management Policy, 29
prohibition repeal, 6

CPSIA information can be obtained
at www.ICGtesting.com
Printed in the USA
JSHW041135221020
8973JS00007B/192